A–Z

OF

CANTERBURY

PLACES - PEOPLE - HISTORY

Naomi Dickins

AMBERLEY

First published 2020

Amberley Publishing
The Hill, Stroud, Gloucestershire, GL5 4EP
www.amberley-books.com

Copyright © Naomi Dickins, 2020

The right of Naomi Dickins to be identified as
the Author of this work has been asserted in
accordance with the Copyrights, Designs and
Patents Act 1988.

ISBN 978 1 4456 9099 5 (print)
ISBN 978 1 4456 9100 8 (ebook)

British Library Cataloguing in Publication Data.
A catalogue record for this book is available
from the British Library.

Typesetting by Aura Technology and Software
Services, India. Printed in Great Britain.

Contents

Introduction

The south of England is peppered with storybook towns, built from medieval churches, red-brick houses and twisting, cobbled streets. Towards the eastern edge of Kent, before the myriad greens of the high Kent Downs dissolve into the mercurial blues of the coastal marsh, there lies just such a town. Side-stepped by the M20 and by-passed by the modern A2, it would appear isolated and somewhat off the beaten track, like so many other quaint, little, out-of-the-way places. But this is Canterbury: quaint and little, maybe, but out-of-the-way? Never. These medieval streets hug the gleaming, Caen stone towers of a cathedral which is mother church to a global congregation; they straddle the convergence of a network of ancient thoroughfares which connected their historic inhabitants with their faraway fellows in London, France, Rome and, thence, the rest of the known world. Today's Canterbury also offers internationally acclaimed schools and universities, nationally recognised theatres, sports and arts venues and a plethora of cultural festivals and events with both local and national appeal; perpetuating a centuries-old tradition of pilgrimage, Canterbury continues to draw visitors from all over. Ever-evolving and forward-facing, Canterbury is a modern, vibrant and cosmopolitan city, founded on a dense and diverse heritage spanning two millennia and, perhaps, more...

This book aims to tell the stories of some of the places and people of Canterbury, past and present, illuminating just a few of the colourful threads that make up the city's vivid tapestry.

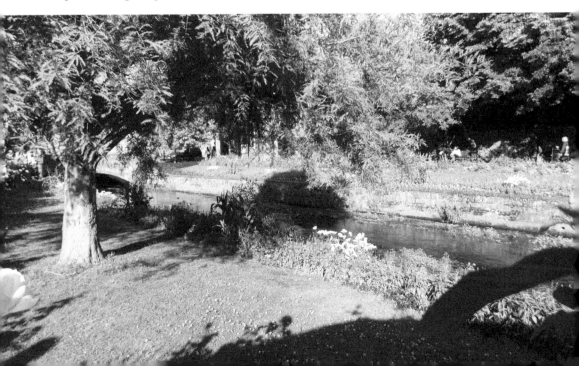

Aethelberht

Born in the mid-sixth century, Aethelberht was ruler of Kent from around 589 to 616 and was the first of England's kings to convert to Christianity. The Venerable Bede drew up a pedigree for Aethelberht, tracing his line back to Hengist, traditionally given as Kent's first Jutish king, but there is little certain evidence about his early life. The kings of Kent had nurtured a strong relationship with the Frankish kingdom across the channel, largely based on a trade in luxury goods, and Aethelberht was married to Bertha, a daughter of the Frankish king Charibert, probably during the 580s. A committed Christian, Bertha was accompanied to England by a retinue which included her chaplain Liudhard and it is believed that Aethelberht had a defunct Roman church restored for his queen's private devotions upon her arrival in Kent.

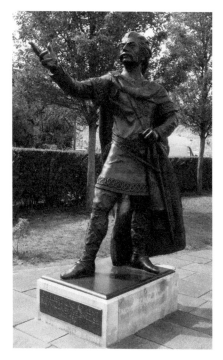

Aethelberht, Saxon King of Kent and the first English king to be converted to Christianity in 597.

This church was dedicated to St Martin of Tours and was to become the epicentre of St Augustine's first mission in Canterbury.

In the *Anglo-Saxon Chronicle* for 827, Aethelberht is listed among those men accorded the title *Bretwalda*. The precise definition of this title is ambiguous, but it is apparent that Aethelberht held a position of influence over the southern kingdoms of the Anglo-Saxon Heptarchy, including Essex and East Anglia. Aethelberht's nephew Saeberht, king of the East Saxons in Essex, followed his uncle's lead in converting to Christianity around the start of the seventh century.

Alluvia River Sculptures

Kent-born artist Jason deCaires Taylor was inspired by John Everett Millais' romantic painting *Ophelia* to create this stunning underwater art installation. Constructed from non-toxic, marine-grade cement, recycled glass and silica resin, the sculptures are visible from the Westgate Bridge and are illuminated at night so that they appear to glow under the river's surface. Taylor is known internationally for his eco-art

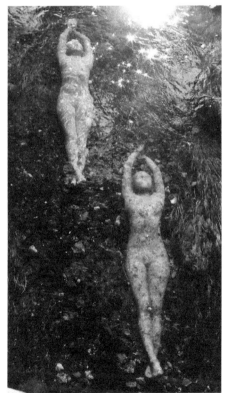 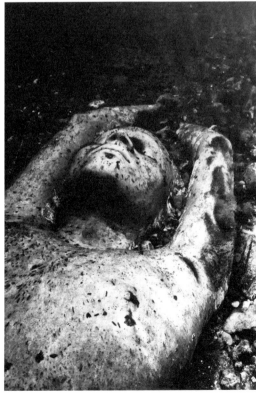

Above left and right: Alluvia river sculptures by Jason deCaires Taylor. (Photograph: Jason deCaires Taylor)

marine installations, which are designed to provide underwater habitats and located to promote marine life regeneration. His work was featured in a 2010 Greenpeace global warming awareness campaign and his Underwater Sculpture Park off the west coast of Grenada, created in 2006, has been listed as one of the twenty-five Wonders of the World by National Geographic.

The *Alluvia* project – its title a reference to the sand deposits made by the river's rise and fall – was installed in 2008 and depicts two female figures lying with feet crossed and arms outstretched above their heads. In the years since their creation, the sculptures have become shrouded in the naturally abundant river weed and algae, making it difficult to glimpse the forms beneath. Alterations in light and river water levels, as well as seasonal environmental changes, can all affect how much of the sculptures is visible, meaning that no two sightings of the ethereal figures are ever the same.

Saint Augustine's Abbey

Saint Augustine's missionary brotherhood arrived in Kent in 597. This forty-strong group, sent by Pope Gregory to complete his attempted conversion of the English, was met by a pagan – but not hostile – ruler, King Aethelberht, who granted them permission, land and freedom to establish a working Christian church on the eastern perimeter of the city; Aethelberht had converted to the Christian faith by the year 601 (when Pope Gregory addressed him as a 'Christian King'). The function of the abbey was, essentially, as a residence for Augustine's team and it would also provide a burial place for the brethren – including Augustine himself, in 604 – and for Kent's kings. The stone edifice was consecrated in 613 and, over the next two centuries, Augustine's abbey would prove itself as a seat of education and as a centre of manuscript production. Originally, the abbey was dedicated to Saint Peter and Saint Paul but Saint Dunstan, during his office as archbishop, called for its rededication to Saint Augustine in 978. In 1030, the relics of Saint Mildrith, Anglo-Saxon Abbess of Minster-in-Thanet, were translated to Saint Augustine's.

St Augustine's Abbey.

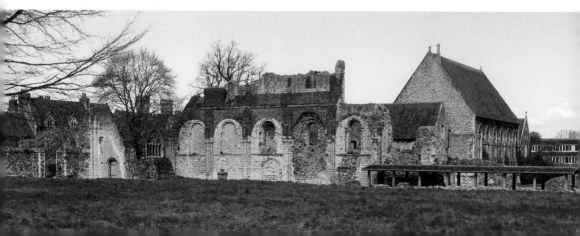

Beaney House of Art and Knowledge

Canterbury-born surgeon James Beaney (1828–91) bequeathed the city £10,000 for 'the erection and endowment of an institute for working men'; having forged a career for himself as a doctor and politician in Australia, the philanthropic Beaney was acutely aware of the value of education – especially for those born, as he had been, into the working class. This Tudor Revivalist-style building, which was designed by surveyor A. H. Campbell to incorporate both Beaney's institute and the city's museum and library, was opened to the public on 11 September 1899. Other significant benefactors included Joshua Cox and the influential Slater family. An £11.5 million refurbishment, begun in 2009, transformed the Victorian space to accommodate larger galleries and

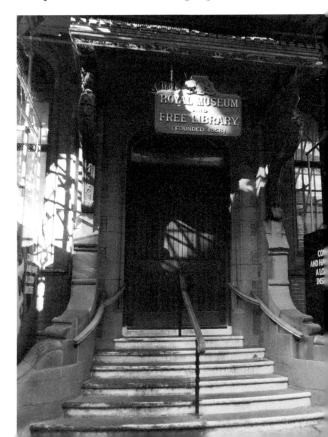

The Beaney Institute.

improve access. The gallery's collections now include works by Thomas Sydney Cooper and a £1 million portrait of Sir Basil Dixwell by Van Dyck as well as archaeological finds from across the region such as Anglo-Saxon grave goods and pilgrims' tokens from the Becket shrine.

Becket, Thomas – St Thomas of Canterbury (*c.* 1119–70)

Becket was born into a Norman family of moderate means in Cheapside in the winter of 1119 or 1120. He was well educated and secured a place in the household of the Archbishop of Canterbury, Theobald of Bec, who might have been related to the Becket family. Thomas became a trusted member of Theobald's household, rising to the position of Archdeacon of Canterbury whilst in his thirties and becoming Chancellor to the King, Henry II, in 1155. Thomas and Henry worked well together; although his position had originated in the church, Thomas was not ordained and he seemed to place the government of state – and loyalty to the king – above all other matters. It was known that the two had formed a close and trusting friendship – so much so, that Henry's son was fostered in Thomas' household – and, when Thomas was elected to the archbishopric upon Theobald's death in 1162, it is understandable that Henry took his Chancellor's loyalty for granted; but he was mistaken. Newly ordained and consecrated, from 1162, Thomas resigned his post as Chancellor and appears to have experienced some sort of religious epiphany. As he began to place the concerns of his church above those of the state, a rift began to develop between the archbishop and the king. As Henry attempted to assert royal authority over the English Church, so Thomas became increasingly belligerent in his defence of the supremacy of Rome. The feud resulted in Thomas' flight to France in 1164, threatening excommunication and an interdict against his sovereign. Diplomatic intervention by the Pope allowed for Thomas' return to England in 1170, but the archbishop was unrepentant and maintained his stance of defiance in the face of Henry's actions and demands. Thomas' excommunication of the Archbishop of York and bishops of Salisbury and London is alleged to have triggered an angry rant from Henry, and some of his words were interpreted by certain of his knights to mean that the King wished his former ally dead: Richard le Breton, Hugh de Morville, Reginald fitzUrse and William de Tracy took it upon themselves to carry out what they believed to be the king's wishes and, on 29 December, arrived at Canterbury Cathedral to confront its archbishop. A graphic description of the encounter is given in the account of Edward Grim, who was witness to the attack:

> the crown of his head was separated from the head in such a way that the blood
> white with the brain, and the brain no less red from the blood, dyed the floor of

the cathedral. The same clerk who had entered with the knights placed his foot on the neck of the holy priest and precious martyr, and, horrible to relate, scattered the brains and blood about the pavements, crying to the others, 'Let us away, knights; this fellow will arise no more'.

The archbishop's murder sent a shockwave through Christendom: barely two years later, Thomas was canonised and St Dunstan's Church and the cathedral at Canterbury became sites of pilgrimage. The cult of St Thomas was immediate and attracted followers from across Norman Europe; his tomb was visited by Louis VII of France in 1179 and William, King of Scotland, had his new abbey at Arbroath dedicated to the saint in 1197. Elaborate and expensive gold, jewelled and enamelled caskets were created at Limoges to carry the saint's relics and an ostentatious shrine was erected at Canterbury in 1220. During the horror of the Black Death in the 1340s, Thomas' shrine received thousands of visits from thankful or desperate pilgrims from all over

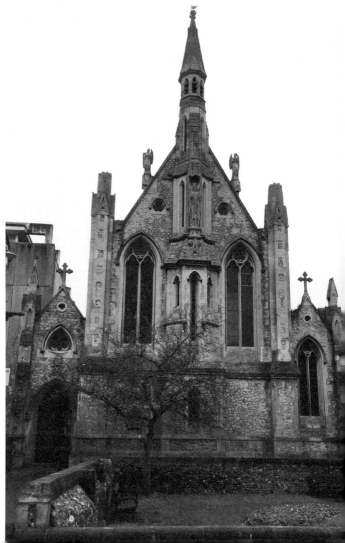

Above: A solitary candle marks the site of the shrine of Thomas Becket.

Right: Roman Catholic church of St Thomas of Canterbury.

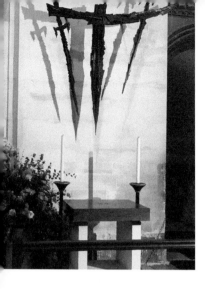

The Altar of the Sword's Point, by Giles Blomfield.

the country. When Henry VIII and Thomas Cromwell began their Dissolution of the Monasteries, they took great pains to suppress the cult of St Thomas: Henry had him portrayed as a traitor to his monarch and the Church of England and demanded that all traces of the saint's mortal remains were completely destroyed. In 1986, a new 'Altar of the Sword's Point' was installed in the north-west transept with a striking sculpture by Giles Blomfield above: each of its two swords positioned either side of the central cross casts its shadow, representing the four knights responsible for Becket's death.

The Roman Catholic church of St Thomas of Canterbury, which opened in 1875, houses relics of the saint: a piece of his vestments and two fragments of bone which came from Gubbio, Italy. A piece of one of the saint's fingers, from a monastery in Pontigny, France, was gifted to the church in 1953 by Fr Thomas Becquet, a descendant of the martyr's family. In 2016, a fragment of bone believed to be a piece of Becket's elbow was returned to Canterbury Cathedral after an 800-year sojourn in Hungary, at the Catholic Basilica of Esztergom – Becket had been a classmate of the city's Archbishop Lucas.

In more recent history, Thomas has been adopted as representative of the struggles of the oppressed against tyranny, as a symbol of independent defiance against oppression and as a champion of religious liberties.

Behn, Aphra (1640–89)

Aphra Behn's real life was the stuff of historical fiction: writer, poet, playwright, translator and spy, Behn is regarded as a significant role model for professional female authors. Born near to Canterbury – possibly in Sturry or Wye – on the eve of the English Civil Wars, very little factual evidence about her life exists, but legend has it that Behn's adventures began when she worked as a king's spy in Surinam and in Antwerp during the 1660s. Writing under the pseudonym 'Astraea', Behn garnered an impressive literary reputation during her lifetime and her circle of friends included poets and artists such

as John Dryden, Edward Ravenscroft and the Earl of Rochester. Behn was one of the country's leading playwrights of the 1670s and, although her political sympathies – monarchist, Stuart, and Tory – and her perceived loose morals provoked public attack, her death, in 1689, signalled a flood of poetic elegies in her honour.

Bell Harry Tower

This stunning example of Gothic architecture was designed by John Wastell in 1498 and its construction was completed by the start of the 1500s. Wastell was a master mason who worked extensively right across the country; he was also responsible for the fan vaulted ceiling of the chapel at King's College, Cambridge.

Although the 250-foot (75-metre) central crossing tower at Canterbury is *faced* with Caen stone to match the rest of the cathedral building, Wastell's stroke of genius was to *build* it from brick – a far lighter material – and to incorporate huge windows to further lighten the structural load. The present 'Bell Harry' was cast by Joseph Hatch of Ulcombe in the 1620s, but the tower derives its name from the original 'Bell Harry'

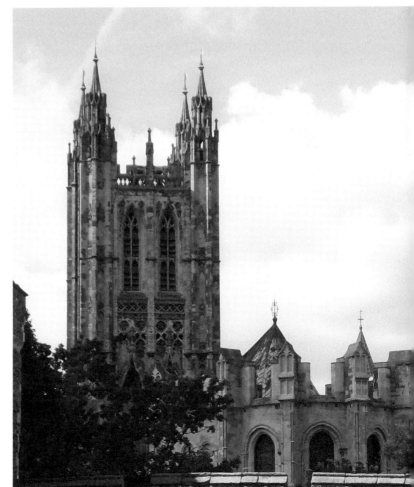

The cathedral's central crossing tower – also known as 'Bell Harry Tower' – as seen from the city wall.

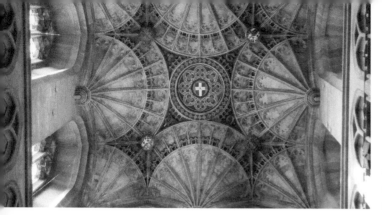

The Bell Harry Tower fan vaulting hides a secret trapdoor.

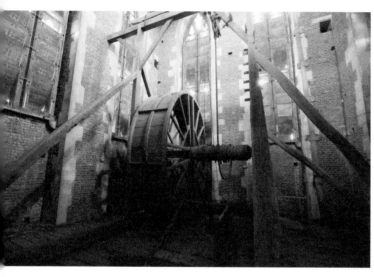

The treadwheel used in the tower's original construction was still working in the 1970s. (Photograph reproduced courtesy of the Chapter of Canterbury)

given by Prior Henry of Eastry in 1288, and moved here from its position in the north-west tower when the central tower was completed. The fan vaulting at the centre of the tower ceiling is a particularly fine and elegant example of this Gothic technique. Close inspection reveals the details of its decoration: the blue and white arms of Christ Church Priory are surrounded by the letters 'P', 'T' and 'G' (for Prior Thomas Goldstone), but what many do not know is that the shield is a secret trapdoor, behind which is hidden the treadwheel or 'hamster wheel' used for lifting materials and tools in the tower's original construction. Although deemed unfit for use by modern health and safety standards, the winch and pulleys were fully functioning and used as recently as 1974.

Queen Bertha (c. 565–601)

The marriage of King Aethelberht of Kent to the Frankish princess Bertha in 580 was made on condition that Bertha be permitted to continue in her Christian faith and so it was that, with Bertha, Christianity returned to England over a decade before the arrival of Saint Augustine. Raised near Tours, in France, Bertha was particularly devoted to Saint Martin and her private chapel in Canterbury, a restored Roman

chapel, was dedicated to him. The present-day Saint Martin's Church occupies this site and the building incorporates a section of the wall of the original Roman edifice (*see* Saint Martin's). Bertha's personal chaplain, Liudhard, travelled with her from France and a gold medallion inscribed with his name was among the coins of the Canterbury (Saint Martin's) Hoard, discovered near the church in the 1840s.

Bertha's influence was instrumental in the establishment of Saint Augustine's mission in England and Pope Gregory wrote a personal letter of thanks expressing his admiration for the queen's faith and level of education. In the city wall opposite Lady Wootton's Green is a bricked-up section which was once an opening known as the 'Queningate' – named in honour of the Queen's passing through so often on her journey to and from her church. The route she walked is now a marked footpath leading from the cathedral's south-west door to the church of St Martin, Queen Bertha's private chapel. A statue of Bertha and one of her husband, Aethelberht, stand on Lady Wootton's Green.

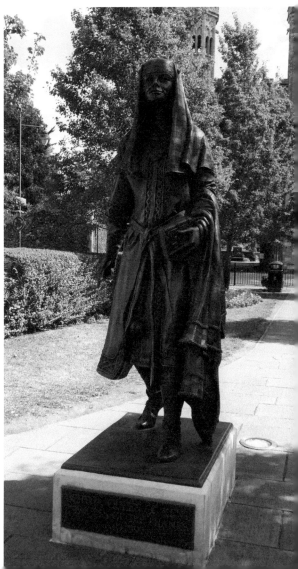

Above: Queen Bertha's Walk waymarker.

Right: Queen Bertha. Her marriage to Aethelberht brought Christianity back to Kent in the 580s.

Blackfriars

Canterbury's Dominican priory, which spanned the River Stour, dates from 1237, when permission for its foundation was granted by Henry II. What remains of the complex today are the buildings that survived a century of systematic demolition following the Dissolution of the Monasteries. The refectory (on the river's east bank) and the friars' guest hall, across the river, once served as a comfortable hostelry for preachers and academics en route between London and the European universities. After serving some time as a weavers' workshop, private home and store, the building fell into ruin but was restored by local residents and since used as a community hall.

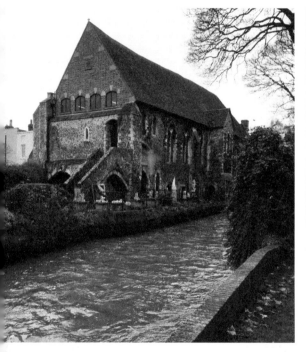

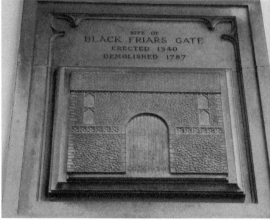

Above: Blackfriars' gate stone.

Left: Blackfriars' refectory.

Below: Blackfriars' guest hall and refectory. The Dominican priory buildings straddled the river.

The Buffs (Royal East Kent Regiment)

One of the British army's oldest infantry regiments, the Buffs can trace their history back to Queen Elizabeth's support for Dutch Protestants in 1572. Formally incorporated into the British army in 1665, the 'Holland Regiment', as they were known, would later be referred to as 'the Buffs' due to their distinctive, sandy-brown-coloured waistcoats and uniform facings. The East Kent Regiment (as they have been known since 1782) has seen action in the Jacobite Rebellions, the American War of Independence, the Napoleonic Wars and the Crimea and served in the Zulu War, the Boer War and across India before being deployed in both World Wars. In 1961, the East and West Kent Regiments were merged to form the new 'Queen's Own Buffs, The Royal Kent Regiment'. This was merged again in 1966 to form The Queen's Regiment.

Right: The Buffs' Chapel, Canterbury Cathedral.

Below: The Buffs' Memorial.

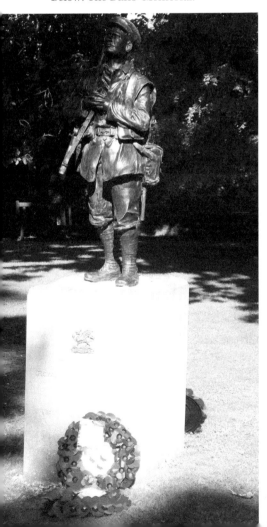

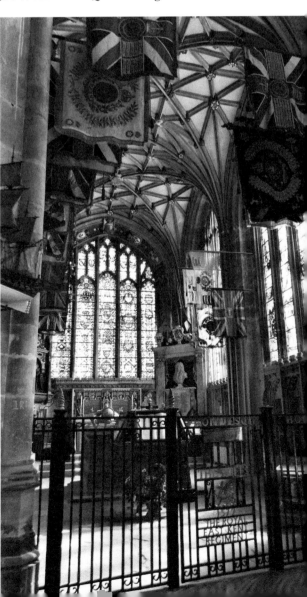

Burgate

This was one of the earliest gates into the city; its name – literally the 'gate of the borough' – has Saxon and possibly even Roman origins but it was also sometimes known as St Michael's Gate in reference to the nearby church. In April 1322, Bartholomew de Badlesmere was tried and executed for his part in the rebellion of the Earl of Lancaster: his severed head was displayed on the Burgate and his body was left to hang at Blean until he was finally buried – possibly at the Whitefriars. There are records of the ancient, wooden gate being rebuilt in brick and stone in 1475 and repairs were later made to it using stones from the newly suppressed Saint Augustine's in the 1540s. The gate was partially dismantled in the 1780s and its demolition was completed in the 1820s when the street below was widened. Although the gate itself is long gone, a few pieces of masonry remain and its position in the

Burgate.

Burgate House.

Inset: The maple leaf emblem reflects the contribution of the Canadian people to the building of Burgate House.

wall is labelled with a cracked Cozens stone* whilst its footprint on the road is clearly demarcated by coloured paving stones at the junction with Lower Bridge Street.

Burgate House is an imposing, modern building erected in 1950 on the site of a large bomb crater caused by air raids in 1942. Canada gave a generous contribution to the project's funding – a gesture which is referenced in the maple leaf motif used in the building's iron works.

Butchery Lane

Today, this narrow alley running off Burgate is a quiet, attractive street filled with shops and cafés, but it was once the bustling heart of city trade when it housed the shambles and weekly meat, fruit and vegetable market. During the 1700s, the slaughterhouse was sited in the middle of the street. Rooms in the White Bull overlooking this street were cheaper to rent than those overlooking the more pleasant aspect of the Buttermarket on the other side of the building.

Butchery Lane.

Butterfly Garden

This flowery oasis is located along Pound Lane, in a space created in the 1980s by the demolition of two houses. From early spring snowdrops to late winter aconites, the garden is planted with colourful and scented varieties most attractive to wildlife. It was created in 2010 by the Canterbury Society, an organisation which aims to enhance and preserve the quality of life of Canterbury's residents, in memory of local author Kenneth Pinnock. After his death, Pinnock's book *A Canterbury Childhood* won the 2009 John Hayes Award and his family donated the prize fund to the garden's construction.

Buttermarket

From the twelfth century this area was referred to as the Bull Stake as it was here that bulls were tied overnight before being taken to slaughter in Butchery Lane; in the fourteenth century the imposing Bull Inn was named to reflect this. Now dominated by the city war memorial, this was once the site of the city high cross, a place where public proclamations were made, where penitents were flogged and even where the condemned were executed. John and William Somner opened a market hall, meeting rooms and theatre here in 1664; their establishment stood on the site for a century, its rents supporting the Eastbridge Hospital. After the theatre's demise, the city corporation built a new, covered marketplace in the 1790s, which was also the place where open voting took place in elections prior to the Ballot Act of 1872.

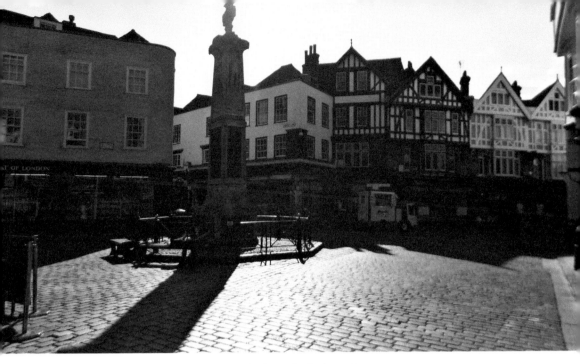

Above: The Buttermarket square outside the cathedral precinct.

Below: The Old Buttermarket.

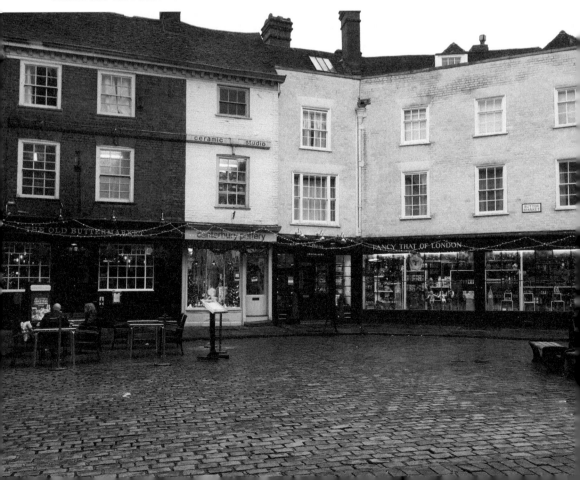

Cade, Jack

The self-styled 'Captain of Kent', Jack Cade made his name as leader of a 4,000-strong rebellion against Henry VI during the summer of 1450. Under the pseudonym 'John Mortimer', Cade demanded the removal of several of the king's advisors and led his followers to an early military victory at Sevenoaks, but his success was short-lived: at Canterbury, the people barred the formidable city gates and Londoners quickly routed the rebel force from the capital. Captured in his native Sussex, Cade died on 12 July.

Canterbury Cathedral

The seat of the worldwide Anglican Church, Canterbury Cathedral is, today, protected as a part of the Canterbury World Heritage Site and is regarded as the foundation stone of the global Anglican community. However, the story of this building is one of constant development and evolution, from its humble origins as a temple in Roman-occupied Canterbury. The Saxon church replaced by the Norman cathedral appears to have evolved from the original, modest structure of around 597 to a substantial edifice not very different in size from its Romanesque descendant. A major rebuild was undertaken in the wake of the Norman Conquest, with further enlargement and improvement after a disastrous fire in the 1170s; an earthquake in 1382 caused major structural damage (and cost the cathedral its campanile), so renovations were undertaken then, and the cloisters were remodelled at the end of the fourteenth century.

In 1433, work began on the great crossing tower and both north and south transept apses were replaced within the century. The cathedral was suppressed in 1539 and the hugely popular shrine of Thomas Becket destroyed, but the New Foundation was established in 1541, and the cathedral's monastic chapter was replaced by the now familiar dean and canons. During the 1640s, the cathedral fell victim to the iconoclasm of the Civil War and Cromwell's soldiers stabled their horses in the nave. The nineteenth century saw more renovation and conservation work and it was in 1834 that the last major building project was undertaken: the 'Arundel Tower' was constructed to replace the less decorative Norman north-west tower, which was demolished.

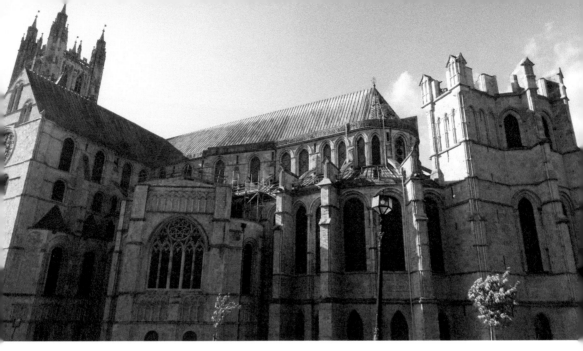

Above: The cathedral's recently restored eastern end – the Corona, Trinity Chapel and St Anselm's Chapel.

Right: The cathedral's south-west transept.

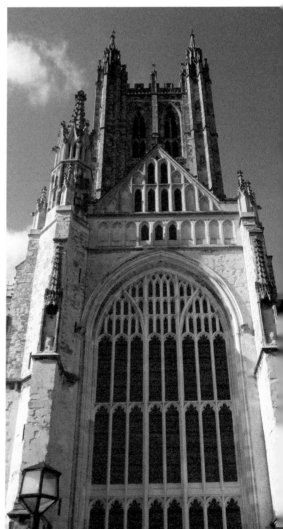

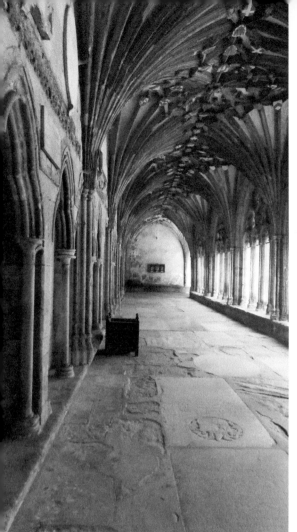
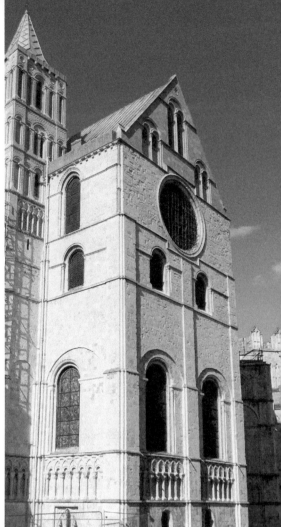

Above left: The cathedral cloisters.

Above right: The south-east transept tower.

In the twenty-first century, the cathedral and its precinct are undergoing a major overhaul. The Canterbury Journey will see the western end of the cathedral, the nave roof and the Christchurch Gate restored, whilst the precinct will be completely reworked to improve access. A new Welcome Centre and Community Studio will offer a range of events and activities as well as exhibitions about some of the cathedral's exquisite treasures.

Castle

The people of Canterbury offered no resistance to the coming of the Normans and their settlement of the area was peaceful; the construction of a castle was begun immediately and it is recorded in Domesday that compensation was offered to the

town for the eleven houses demolished to make way for the castle bailey. This original castle was a timber and earthwork motte-and-bailey construction, centred upon the ancient mound which is, today, preserved as a monument in the Dane John Gardens. This mound's position in relation to the Roman wall presented a shelter curtain on the south-eastern corner of the castle complex which served for protection and defence of the early fortification, but the temporary timber castle was soon abandoned for a more imposing, and permanent, stone structure, the remnants of which stand to this day. The alacrity with which the castle at Canterbury was built points to the strategic importance – and vulnerability – of the town, positioned as it is at the junction of the major roads linking Kent to London and the Continent.

The stained and weather-worn ruins of the Norman castle visible today give little hint of its former glory. Construction of the castle began in 1085, making it one of the earliest of the 'tower keep' type castles, being almost contemporary with – and very similar in design to – the White Tower (of London), which was begun in 1070. Along with Rochester and Dover, Canterbury was one of three royal castles in Kent and much work was done in construction and improvement during the reign of Henry I. Originally three storeys tall and with an entrance on the western side (and a postern gate into what is now Church Lane), the square, solid castle was built from flint and rubble with some sections of Duke William's favourite Caen stone: it would have loomed with indomitable Norman authority over the modest, low-level architecture of the Saxon skyline.

Below: Remains of the Norman castle keep, which once stood three storeys tall.

Inset: The castle at Canterbury was one of the original Norman 'tower keep' style castles, like the White Tower in London.

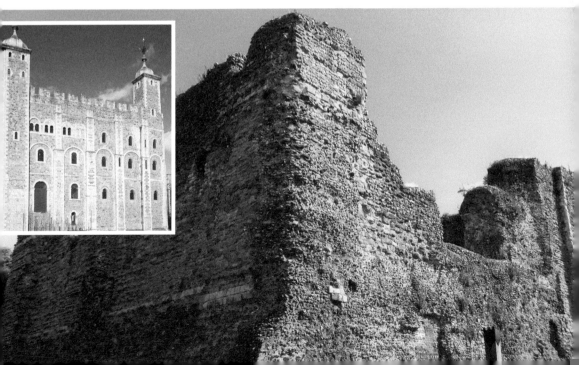

The bailey for this castle was large and square, its perimeter defined and defended by an earthwork ditch and bank which roughly followed the line of Castle Row and Church Lane. In some places, parts of the inner wall remain and sections of the outer were incorporated into the medieval reworking of the city walls in the 1300s. On its southern edge, the bailey perimeter was demarcated by the Roman wall and, for its entrance, the castle appropriated the Worthgate. Excavations outside the walls have indicated arable cultivation contemporary with the Norman occupation.

The castle remained a royal possession until the seventeenth century, undergoing substantial repairs during the reign of Richard I and surrendering to the Barons during the reign of his brother, John. Captured by the French in 1216, the castle would also fall prey to Wat Tyler's mob during the Peasants' Revolt. After this, the castle began to fall into disrepair and, finally, was gifted by James I to Sir Anthony Weldon of Swanscombe in 1609, by which time it was described as an 'abandoned ruin'. Partial demolition of the castle in 1817 saw its walls reduced by at least one storey and it was later purchased by the gasworks and used as a coal store. In 1928, it was rescued for posterity by Canterbury City Council and, according to English Heritage, still offers exciting potential for archaeological discovery.

Chaucer, Geoffrey

Perhaps Canterbury's most celebrated 'adopted son', Geoffrey Chaucer might never even have visited the town, but he was well aware of the city's significance at the centre of the English Church and of its popularity as a site of pilgrimage: Chaucer imagined a motley rabble of pilgrims heading for the Becket shrine and his *Canterbury Tales* are the stories they tell each other on their journey to pass the time.

Although now largely remembered for just one literary work, Chaucer was a prodigious and innovative author – celebrated in his own lifetime – championing the English language and writing in the vernacular so that his work might be widely read. However, it was as a diplomat and courtier that Chaucer made his living: related by marriage to John of Gaunt and a key figure at the court of Edward III, Chaucer was a trusted advisor to the king and his sons and tasked with a number of sensitive negotiations on the monarch's behalf. He fought alongside the Plantagenet princes from an early age and, when the teenaged Geoffrey was captured in battle, the king made it his personal business to pay the young soldier's ransom.

The statue of Chaucer that now stands in Canterbury High Street was created by sculptor Sam Holland and was unveiled in 2016. Its plinth, created by sculptor Lynne O'Dowd, is illustrated with depictions of characters from *The Prologue* of *The Canterbury Tales* represented by 'personalities' with a local connection, such as actor Orlando Bloom and former High Sheriff of Kent Hugo Fenwick.

Above: This lion-like effigy is carved just above the doorway to the building; it is possibly evidence of a connection with Edward of Woodstock.

Left: The Checker of the Hope.

Christchurch Gate

Despite the bold inscription across its middle, stating that the gate was constructed in 1507, cathedral documents record that its building work was carried out between 1504 and 1521. Just over a century later, when the cathedral became a target of Cromwell's 'Blessed Reformation', the notorious Richard Culmer oversaw the gate's destruction; in 1643 Clergyman Thomas Paske described the fury with which he witnessed soldiers attacking the effigy of Christ, detailing how they shot at his head and face 'as if they were resolved to Crucifie him againe'. Restoration of the gate began with the return of the King in 1660. In 1803, Alderman James Simmons ordered that the gate's flanking towers be removed so that he might have a view of the cathedral clock from his High Street office, however, these were replaced during a later restoration project funded by the Wills family in the 1930s. The imposing figure of Christ which now overlooks the Buttermarket from the gate's centre is a bronze created by German sculptor Klaus Ringwald and was installed in 1990.

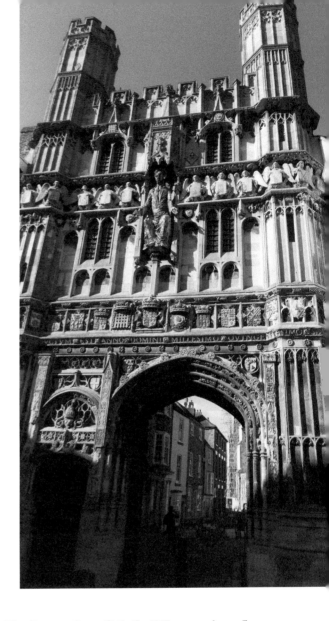

Christchurch Gate.

Cogan House or Cokyn's Old Hospital

The Cokyn family is recorded in the Domesday Book as an ancient Canterbury family associated with the Worthgate ward. This building, in St Peter's Street, is named for John Cogan (or Cokyn), who came into possession of the property in 1626. Hasted tells us that the property had been previously used as a hospital, after it was acquired by William Cokyn sometime before 1160. William bequeathed his entire estates to the maintenance of the hospital but it was incorporated into the St Thomas hospital, Eastbridge, in 1230 and this building was leased to generate income for the institution. Today, its Victorian exterior gives little indication of this building's antiquity but the interior still retains a wealth of Tudor features.

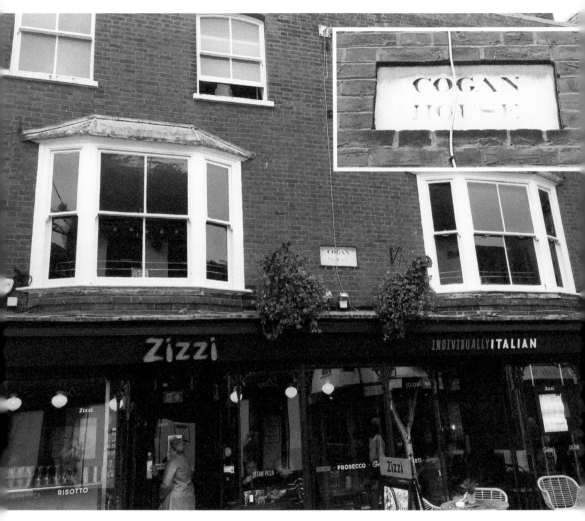

Cogan House or Cokyn's Old Hospital, St Peter's Street.

Conrad, Joseph (1857–1924)

The only child of his noble Polish parents, Conrad was born into the turmoil and danger of Russian-occupied Ukraine during the reign of Emperor Alexander II. His life would play out like the action from a novel – exiled, orphaned, rescued by a generous uncle, the young Joseph would travel the world and explore its hidden corners during a fifteen-year career at sea. An extremely hard-working and dedicated writer, Conrad created some of his major works, including *The Heart of Darkness*, in his few spare hours aboard ship; however, it was after his retirement to Bishopsbourne that he began to write in earnest, publishing new works almost every year from 1895 until the time of his death in 1924. He is buried, with his wife, Jessie, in the city's Westgate Court Avenue Cemetery.

Cooper, Thomas Sydney (1803–1902)

Cooper was born in Canterbury and showed artistic talent from an early age. He worked for some time as a drawing master and became a student at the Royal Academy before exhibiting his first piece there in 1833. The majority of Cooper's work is pastoral, featuring sheep and cattle and, for this reason, he was sometimes referred to as 'Cow Cooper'. Despite becoming a Royal Academician in 1845 and receiving the Royal Victorian Order from King Edward VII in 1901, Thomas never forsook his Canterbury roots: he provided alms for the city's poor at Christmas and established a thriving art school here, which was to become the University for the Creative Arts. Thomas' nephew, William Sydney Cooper, a fellow landscape painter, was to follow in his uncle's footsteps, recording the beauty of the Kent countryside. The Sydney Cooper Gallery, housed in the original School of Art building, is now a part of the Christ Church University and showcases the work of students and international artists alike.

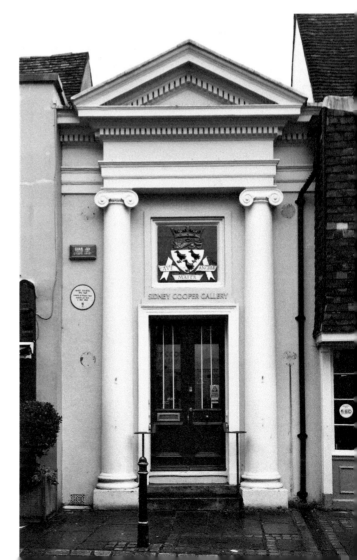

The Thomas Sydney Cooper Gallery in St Peter's Street. Mary Tourtel was a student here.

Dane John Gardens

The city of Canterbury has Alderman James Simmons to thank for the boon of its elegant municipal gardens along the city wall. Having leased a field and hill in 1790, he spent £1,500 on improving the area 'for the use and amusement of the people' of Canterbury. It was agreed that he would level the ground – except for the 'Great Hill' – and create a safe walkway along the wall; the land was to be sown as pasture and a cottage built for the accommodation of a full-time gardener.

The eponymous 'donjon' itself (Norman French for fortified mound) remains something of a mystery; Roman coins found at its base during Simmons' works have led to suggestions it was used as a burial site in the early Roman period but it is likely that it was already an ancient mound – one of perhaps six in the city – at the time of the Roman occupation. Excavations in the 1980s and 1990s also revealed evidence that the mound was repurposed (as at Pevensey, for example) by the Normans as a motte for their original wooden castle.

Within the gardens is the large, imposing South Africa Memorial, paid for by public subscription and erected in 1903 to honour the men of the Buffs and Royal East Kent Regiment who were killed during the Boer War.

Below left and right: Dane John Gardens.

Ducking Stool

The town ducking stool, although later associated with witch trials, was traditionally used for the punishment of wayward wives, regarded by their husbands as unruly or overly independent, and for the castigation of scolds, as well as a means by which

The ducking stool above the Stour.

unscrupulous local tradesmen could be chastised for cheating their fellow citizens: the stool bears the warning, 'Unfaithful wives beware, also butchers, bakers, brewers, apothecaries, and all who give short measure.'[1]

This stool is suspended above the River Stour, just beyond the King's Bridge. Its last recorded use was in 1809.

St Dunstan (909–88)

Born to a noble Wessex family, Dunstan was well educated and, according to his eleventh-century biographer, excelled at 'making a picture and forming letters'. Such was Dunstan's scholarly reputation that he was called to attend the court of King Athelstan, but it was whilst living among the brethren at Glastonbury that Dunstan's artistic talents – in illumination, silversmithing and musicianship – were fully realised. Appointed minister to King Edward the Elder, Dunstan was to become a highly influential statesman, whose strategies were to contribute to a period of peaceful prosperity for the Anglo-Saxon kingdom. However, it is for his work as a church reformer that he is best remembered: beginning at Glastonbury, Dunstan reinvigorated and promoted the Benedictine order; under his influence, it spread rapidly across England and into northern Europe, his reforms restructuring the Church and clarifying Church law. Having been made Bishop of Worcester and London, Dunstan was created Archbishop of Canterbury in 960 and presided over the coronation ceremony of King Edgar in 973; the service which Dunstan created still forms the core of the English coronation ceremony. Eventually retiring to Canterbury, Dunstan spent his final years in prayer and teaching and in artistic and creative pursuits. It is recorded that, having foreseen his own death, Dunstan selected a burial place and died peacefully in his bed. He was canonised in 1029 and was, until the assassination of Thomas Becket, England's favourite saint.

St Dunstan's Church, which is thought to have been built over a Roman graveyard, was sited at a busy road junction and adjacent to a tall, free-standing stone cross, its prominent situation and considerable size attesting to its importance as a Saxon building. It was later chosen as the site for the Roper family vault and chantry. The popular stories of St Dunstan's miracles are captured in stained glass in the north choir aisle at Canterbury Cathedral.

St Dunstan's Church

This is one of Canterbury's pre-Conquest churches, having been founded in the tenth century but rededicated to St Dunstan in 1030, in celebration of his canonisation. After the murder of Thomas Becket, Henry II's pilgrimage of penance brought him to St Dunstan's. Here, he put on a sackcloth shirt and, from this point, the king

walked barefoot to the cathedral. Situated to the west of the city, but outside its walls, St Dunstan's and the area surrounding it would benefit from the pilgrimage industry associated with the story of St Thomas Becket, providing refuge, accommodation and sustenance for pilgrims arriving after curfew.

The church's St Nicholas Chapel, one of the earliest brick buildings in the city, was the chantry constructed for William Roper in 1525 as a replacement for that of his forebear John Roper, which had been built in 1402. William's wife, Margaret, was the daughter of Sir Thomas More and is believed to have brought her father's severed head here from London Bridge – where it had been displayed on a pike after his execution in 1535 – to have it buried with her in the sanctity of her family's church in 1577. When the vault was enlarged, a wall niche was created for More's skull and it remains there to this day. The chapel's stained glass depicts scenes and stories from More's life and career.

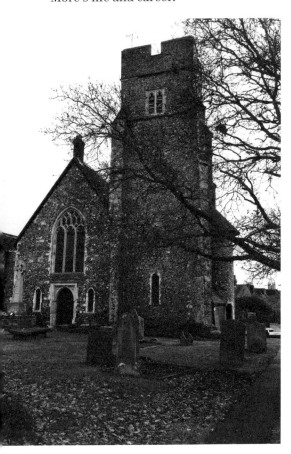

Above left: St Dunstan's Church.

Above right: The St Nicholas Chapel at St Dunstan's Church – one of the earliest brick buildings in the city.

Eastbridge Hospital

Sometimes referred to as the King's Bridge Hospital, the Hospital of St Thomas the Martyr of Eastbridge might have been founded by Thomas Becket during the reign of Henry II; alternatively, it might have been established during the 1170s to provide sustenance and accommodation for pilgrims travelling to Becket's shrine at

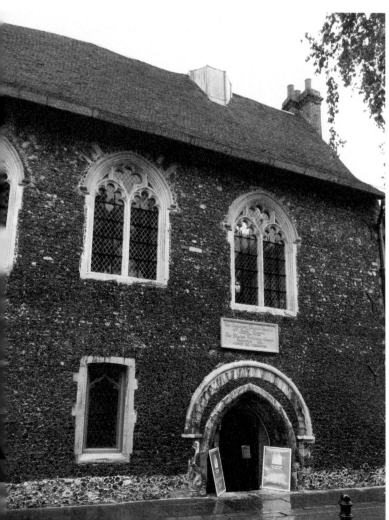

Eastbridge Hospital.

the cathedral. Certainly, the hospital was well-endowed by succeeding archbishops and the conditions under which it provided care for poor pilgrims are recorded as follows: 'every pilgrim ... should have no more than one night's lodging and entertainment, at the expense of 4d...there should be twelve beds'. Income was provided by generous benefactors such as Hamo de Crevecoeur and Sir John Lee and by the support of a number of parishes, including those of St Nicholas at Harbledown and Saints Cosmas and Damian at Blean. Briefly converted to tenements for a period during Elizabeth's early reign, the charity was refounded in 1569 to incorporate a school for twenty boys, which was to endure until the end of the nineteenth century. Today, the institution functions once again as it was originally intended, in providing permanent housing for eight elderly residents – or 'Indwellers' – who live in private, self-contained apartments.

Edward of Woodstock, the 'Black Prince' of Wales (1330–76)

In his will, Edward of Woodstock stated clearly that it was his wish to be buried in the crypt at Canterbury Cathedral and he gave specific, detailed instructions about his funeral and memorial. He stipulated that his tomb effigy – which should be made in gilt bronze – should represent him in full armour and bear an inscription, clearly visible, so that all passers-by might read:

> *... On earth I had great riches*
> *Land, houses, great treasure, horses, money and gold.*
> *But now a wretched captive am I,*
> *Deep in the ground, lo here I lie ...*

His tomb was actually installed in the most prominent position in the cathedral, the Trinity Chapel, to the south of the site of Becket's shrine. Forty years later, Edward's nephew, Henry IV, who had gained the English crown by usurpation of Edward's son, Richard II, elected to have his own tomb placed directly opposite that of his uncle, creating a trio of monuments to three remarkable and prestigious men, which would endure until Henry VIII's destruction of the Becket shrine in 1538.

The eldest son of Edward III and Philippa of Hainault, Edward of Woodstock held a long association with Canterbury and made many generous gifts and donations to the cathedral throughout his lifetime, including funds to improve the Undercroft Chapel of Our Lady, which was once a blaze of jewel colours and glittered with silver-gilt stars. As an expression of gratitude for the Pope's approval of his marriage to Joan Holland, the 'Fair Maid of Kent', Edward commissioned and funded the remodelling of one of the cathedral's chantries – now known as the Black Prince's Chantry (also as the

French Protestant Church). One of the ceiling bosses in this chapel is reputedly a depiction of Edward's beautiful wife.

 Today, the gilt lustre of the prince's effigy has a dull, greenish patina, due partly to its exposure to the elements after Oliver Cromwell's army divested the chapel of its coloured glass. One can only imagine the gleaming spectacle of the tomb in its original condition...

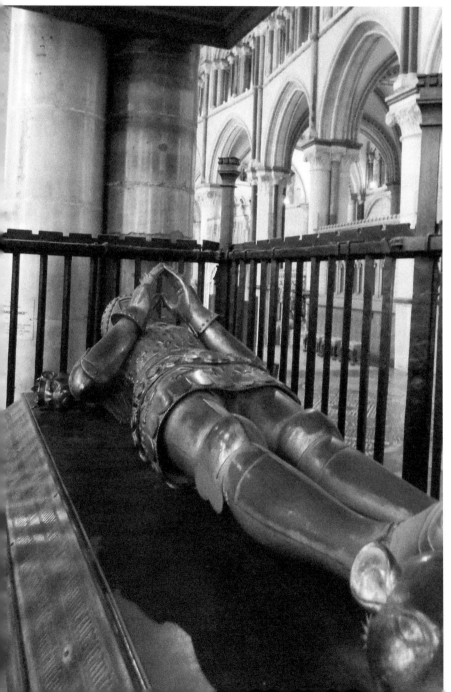

The Black Prince's tomb at Canterbury Cathedral.

F

Fish Market

A fish market at this site is first recorded as being built during the reign of
Edward IV, in 1480, by the Corporation of Canterbury; after a charter in 1448
granted the town the right to collect tolls, a number of markets developed for
all the essentials of medieval life, from daily bread and clothing to floor rushes
and animal feed. The fish market next to St Margaret's Church was popular and
prosperous, but was eventually demolished to make way for the present building,
which was constructed in the early 1800s. Inside, the space was divided between
stone stalls, and a water pump was installed for the fishmongers' use. The elegant,
classically styled, colonnaded building has served as a variety of shops over almost
two centuries.

This elegant, colonnaded building was once the city's busy fish market.

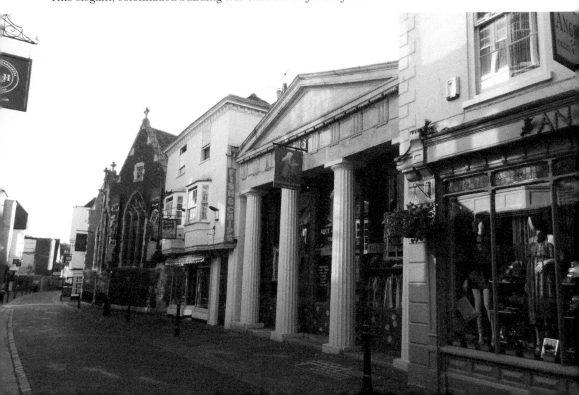

Fyndon's Gate

Thomas de Fyndon served as Abbot of Saint Augustine's from the 1280s until 1309. By all accounts, Fyndon was something of a warrior-cleric, and came to blows with Edward I and his son in disputes over Church privileges. However, he was also widely respected as a fair and dedicated churchman and he oversaw enormous rebuilding and expansion of the abbey complex: during Fyndon's time, repairs were made to the convent dormitory roof, choir stalls and windows and the remains of Saint Augustine were rehoused in a new, elaborate tomb near the high altar. New building projects included a kitchen, the abbot's chapel, the tower and the great gate with its chamber above, which was constructed between 1301 and 1309. The new bedchamber would later host honeymooners King Charles I and his new bride Queen Henrietta Maria after their marriage at the cathedral in June 1625. Charles' sons also stayed at the gatehouse in 1660, by which time it had passed into the possession of Royalist Kent MP Sir Edward Hales and his wife, Anne Wootton.

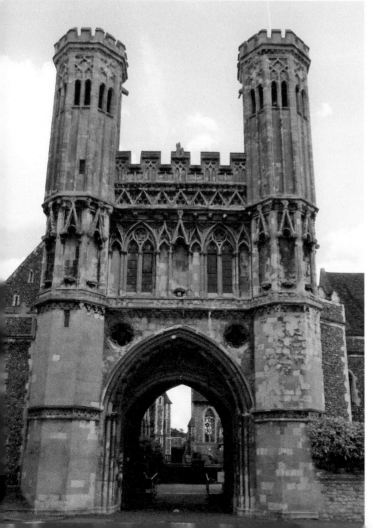

Fyndon's Gate at
St Augustine's Abbey.

G

St George's Tower

This striking, solitary tower is all that remains of the twelfth-century church which was demolished after a disastrous fire in 1942. The Victorian clock survived the blitz but the church building was not restored. A commemorative plaque records the baptism, here, of Christopher Marlowe in February 1564 and it is known that the playwright's father held business premises in the street opposite the church.

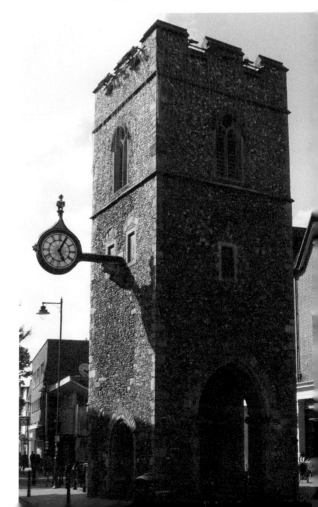

St George's Church Tower.

Gibbons, Orlando

In 1625, Charles I summoned his court composer, Orlando Gibbons, to attend him at Canterbury and supervise a musical accompaniment to the king's first meeting with Queen Henrietta Maria. Gibbons – successful and popular – held the position of organist at the Chapel Royal and Westminster Abbey and was used to fulfilling the demands of the English royal court. Tragically, on 25 June whilst at his lodgings in the cathedral precincts, Gibbons suffered what is believed to have been a cerebral aneurism and died, aged just forty-one. Such was the shock at his death that a post-mortem was demanded and quickly carried out to determine whether or not he had fallen victim to plague. This was proven not to be the case and Gibbons was buried at the cathedral.

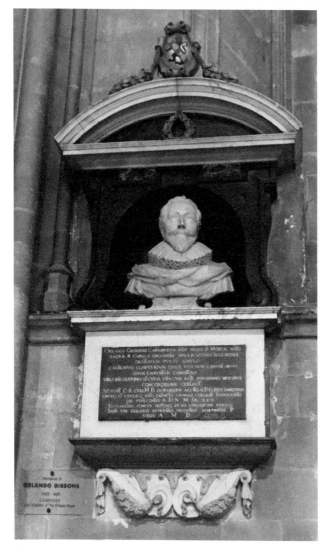

Memorial to Orlando Gibbons in Canterbury Cathedral.

Gulbenkian Theatre

Calouste Gulbenkian was born in Armenia in 1869 and made his fortune in the oil fields of Iraq. He became a British citizen in 1902 but spent his life travelling in search of new acquisitions for his extensive art collection. When he died in 1955, Calouste left a legacy of seventy million dollars to establish an international foundation in his name, concerned with the arts and culture, social welfare and education; that foundation continues its founder's philanthropic work to this day.

As part of the new foundation of the University of Kent at Canterbury in the 1960s, a proposal was put forward for a theatre which would provide an arts venue for both students and the general public. The Gulbenkian Foundation awarded the project a £35, 000 donation and the remaining £81,000 costs were met by the University Grants Committee and the University of Kent Foundation Fund. From the outset, the plan was for a working theatre; a place of education and experimentation where the audience and actor could interact – hence the theatre's thrust stage design. The Gulbenkian was designed, built and fitted on a shoestring budget and opened its doors in the summer of 1969. Its popularity continues to grow and it attracts world-class actors and performers.

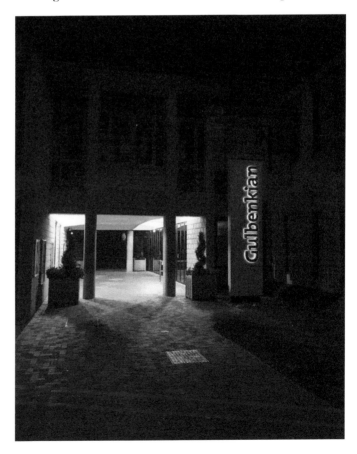

The Gulbenkian Theatre.

Henry IV (1367–1413), King of England (1399–1413)

Henry Bolingbroke took the English throne from his cousin, Richard II, in 1399. The eldest son of John of Gaunt and his wife Blanche of Lancaster, Henry traced his royal bloodline back to Henry III; if some saw this claim as fragile, support from the English people – and Parliament – was strong enough when he returned to England from exile in France to take up his inheritance.

Henry's reign was turbulent and he ruled by military might as much as by law but he bequeathed a consolidated kingdom encompassing both English and French territories to his son, Henry V, in 1413.

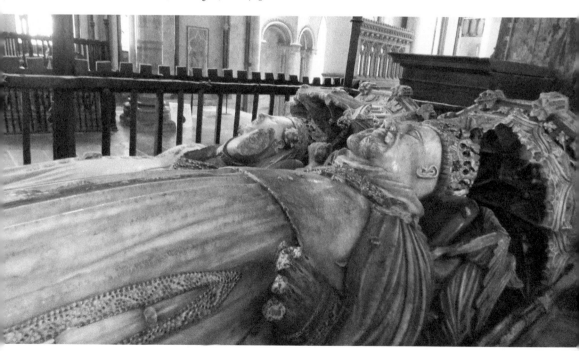

Tomb of Henry IV and Joan of Navarre.

God knows, my son,
By what bypaths and indirect crook'd ways
I met this crown, and I myself know well
How troublesome it sat upon my head.
To thee it shall descend with bitter quiet,
Better opinion, better confirmation,
For all the soil of the achievement goes
With me into the earth.

Henry IV Part 2, Act 4; Scene 3, William Shakespeare

During his lifetime, Henry expressed a devotion to the cult of Thomas Becket, and this goes some way to explaining his connection to the cathedral at Canterbury. Like his uncle, Edward of Woodstock, before him, Henry expressed an early wish – formally recorded in his first will in 1409 – to be interred at Canterbury, rather than Westminster Abbey. At his coronation in 1399, Henry addressed the crowd in English – possibly the only monarch to do so since the Norman Conquest – and he was anointed with holy oil, which was believed to have been a gift from the Virgin Mary, given to St Thomas shortly before he was murdered.

Perhaps Henry had more reason than most to contemplate his own mortality: for much of his adult life he suffered from some violent and debilitating illness – possibly leprosy or syphilis – which saw him incapacitated for significant periods of time and would finally prove fatal in 1413.

Henry IV is the only monarch to have been buried at Canterbury Cathedral and his tomb is situated in the Trinity Chapel, adjacent to the original location of Becket's shrine and opposite the tomb of his uncle, Edward of Woodstock. Historians continue to debate the significance of this placement: was it a triumphant statement of his own equality with the Black Prince – whose son Henry had usurped – and a bold demonstration of the legitimacy of his own bloodline? Or was his decision governed by Henry's desire to be regarded, for eternity, as a rightful Plantagenet ruler and by his genuine respect and admiration for his uncle, the epitome of chivalric dignity?

Iron Age Settlement

In spring 2013, prior to the commencement of building works, a major excavation took place at the site of the University of Kent's newest college, Turing. The archaeological evidence uncovered dates, predominantly, from the early-middle Iron Age, but also indicates settlement stretching from the Bronze Age, possibly connected with a high-status Bronze Age site identified within the city at Castle Street. The Turing College site was discovered to have been divided into 'activity zones' including an area for textiles production and an area for metalworking practice; a clearly defined enclosed field system was apparent and a number of structures, including at least one roundhouse and a number of storage facilities were also in evidence. The large number of finds, including high-quality ceramic items, reveals the extent of occupation and activity at the site to have been significant and suggests possible connections between the resident population and their European neighbours. Despite this, it appears that the settlement was suddenly abandoned around *c.* 100 BCE and was not reused until the medieval period. This site is one of a number in and around Canterbury that have yielded significant Iron Age finds and, together, paint an interesting picture of the pre-Roman occupation of the area: excavations at Bigbury Camp in nearby Harbledown revealed a well-defended, enclosed hillfort – the only confirmed example in east Kent. This was possibly the site – described by Caesar as fortified 'by both nature and artifice' – at which the Britons and invading Romans met in battle in 54 BC.

Ishiguro, Kazuo

Nobel Prize laureate Sir Kazuo Ishiguro was educated at the University of Kent at Canterbury. The multi-award-winning writer and novelist read English and Philosophy, graduating with a BA (Hons) in 1978. He was awarded the Nobel Prize for Literature in 2017 and was knighted for his services to literature two years later.

J

Joan of Navarre, Queen Consort of England (*c.* 1368–1437)

Joan's tomb effigy at Canterbury Cathedral portrays a diminutive figure, alongside her husband, Henry IV. There is another depiction of Joan – again with Henry – in the Coronation Window of George VI. However, these romantic illustrations give little idea of the status and capabilities of Queen Joan, who was, according to Ian Mortimer, 'constant, intelligent and trustworthy ... passionate and determinedly loyal'. Henry's choice of a French bride was not a popular one as England and France were, at the start of the fifteenth century, edging towards war. The union was a second marriage for both parties and made Joan stepmother to the young Henry V. For the most part, these two shared an amicable relationship, until Henry took prisoner Joan's own son, Arthur of Brittany. This action – unsurprisingly – soured their association

Leeds Castle in Kent, where Joan of Navarre was held as a prisoner of her stepson, Henry V.

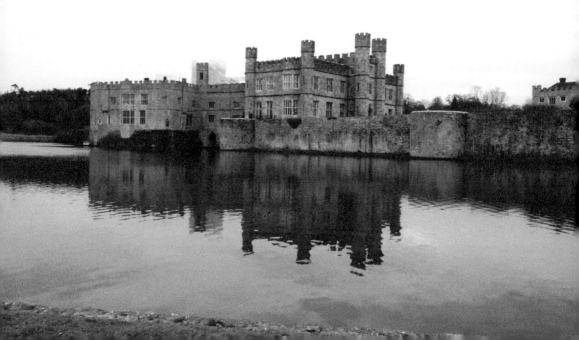

and Joan was accused of using sorcery to poison the King: for this crime, she was stripped of all personal estates and fortune and imprisoned at Pevensey and Leeds castles. Unfortunately – and rather unfairly – despite a complete lack of evidence and despite Joan's proven capabilities as a ruler throughout her long and otherwise respectable life, the stain of the witchcraft accusation upon her reputation is what history has preserved of her. Henry V released Joan from her imprisonment just a few weeks before his death in 1422 and Joan spent the remaining fifteen years of her own life in the peaceful comfort of her own court at Nottingham Castle. It was Joan that commissioned the tomb in which she and her second husband are buried (*see* Henry IV).

Johnson, Hewlett, 'The Red Dean' (1874–1966)

Johnson joined the priesthood at the age of thirty, after an earlier career in engineering and became Vicar of Altrincham in 1908. A dedicated Christian Marxist, he became an outspoken pacifist during the First Word War, a position which made him unpopular despite the approval earned within his parish through his hard work and commitment to the poor.

Highly regarded for his intellectual endeavours in the field of theology and divinity, Johnson secured a promotion to the position of Dean of Manchester in 1924, and in 1931, became Dean of Canterbury Cathedral. Although his unfashionable socialist views had long been in evidence, it was after a tour of the USSR in the 1930s that Johnson's political position came under widespread public scrutiny.

As a pacifist, he was initially opposed to war but, after the Nazi invasion of the USSR in 1941, Johnson changed his position and worked tirelessly for the preservation of Canterbury Cathedral and to help the desperate and dispossessed of the city during the ferocious bombing raids of 1942. He was awarded the Red Banner of Labour for his work for the Committee for Soviet Aid, an honour that was presented at a meeting with Stalin at the Kremlin in July 1945.

Johnson's unfailing support for communism was deemed, by some, to be based on a naïve and insubstantial understanding of the realities of the Soviet regime: he had a romanticised view of life in post-revolution Russia and never addressed the issues of the persecutions and executions perpetrated by Stalin's administration. Johnson, however, maintained that his sympathy was founded on a fundamental belief in the moral basis of the communist egalitarian ideal and he saw no conflict between his political and religious views. A controversial figure until the end, Johnson travelled widely throughout the Cold War, visiting both sides of the 'Iron Curtain'– including trips to Hungary, Australia, USA, China, Russia and Cuba – and patently refused to submit to the demands of his archbishop, Fisher, that he choose between his politics

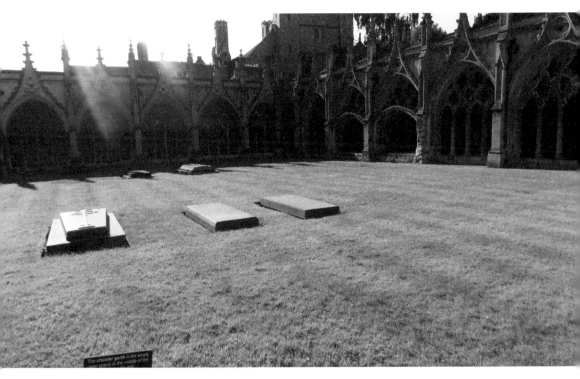

The cathedral cloister garth, where Hewlett Johnson is buried.

and his position. After retirement – at the age of eighty-nine – in 1963, he continued to live in Canterbury at his home, the Red House; he also continued to travel and he became interested in psychical research. Johnson died at the age of ninety-two and is buried in the Cloister Garth at Canterbury Cathedral.

Jutes

The *Anglo-Saxon Chronicle* describes the arrival of the Jutes in Kent in the year 449; it tells of the defeat of the native Britons by Hengest and Horsa and of the eventual victory of Hengest over all of Kent. After this time, the Romanised British name of 'Durovernum' was replaced by the more familiar-sounding name of Canterbury, developed from the Old English 'Cantwareburh', meaning 'Kentish stronghold'.

The precise origins of the Jutish people are disputed and no definitive source has been identified for their native language, but archaeological evidence suggests that their cultural habits were less Germanic than the Angles or Saxons, and more closely related to the Christian Roman and Frankish empires. This affinity with nearby Europe was likely an important factor in the success of the Jutish settlement of Kent, Hampshire and the Isle of Wight.

Kent War Memorial Garden

To the east of Canterbury Cathedral there is a secluded walled garden. Formerly a bowling green, the area was repurposed in 1921 as a memorial garden to the 'the sons and daughters of Kent who died in the Great War 1914-1919'. The location of the county memorial was debated, but Canterbury – and this site in particular – was selected in 1920 and the project was funded by public subscription. The Portland stone memorial cross was designed by a colleague of Lutyens, Kent-born architect Sir Herbert Baker. Baker also designed a number of the Imperial War Graves Commission cemeteries across the Western Front (including that at Tyne Cot) as well as twenty-four English war memorials, ranging from the small village memorials – including those of his own home village, Cobham, and that of Etchingham, in Sussex, which was home to Rudyard Kipling – to those on a much

Kent War Memorial Garden.

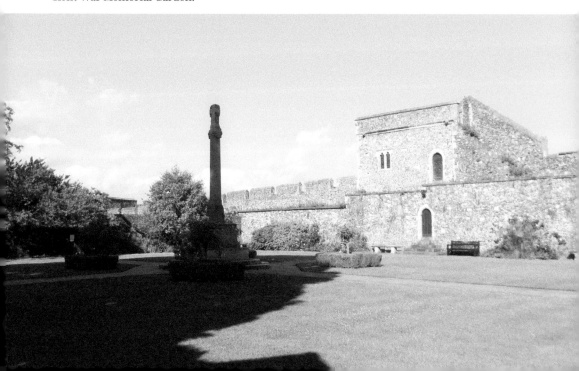

grander scale, such as the Hampshire and Isle of Wight memorial at Winchester Cathedral and the War Cloister at Winchester College.

This memorial garden was officially opened by Lady Camden on 4 August 1921, seven years to the day of Britain's declaration of war upon Germany.

King's Mile

This area, stretching along the outskirts of the King's School premises and out towards the city's northern end, is a vibrant artistic quarter comprising a varied and interesting collection of independent shops and businesses. The original and eclectic mix accommodated here preserves a sense of the medieval origins of the area and many of its buildings.

The King's Mile.

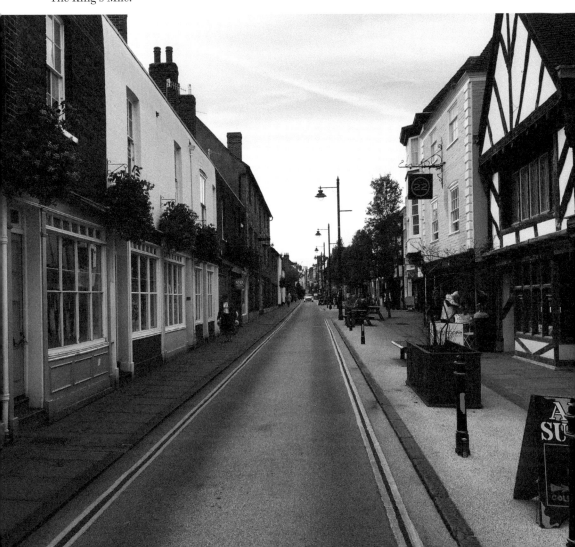

King's Mill

Eastbridge, named for its position on the Stour, was also known as King's Bridge, having been named, originally, for the ancient royal watermill which stood beside it from at least the time of the Norman Conquest. Domesday lists three mills in the city held as royal possessions by King Edward and there is record of this one being granted to St Augustine's by King Stephen in 1144, during the long years of The Anarchy. Purchased by Alderman James Simmons, the mill was demolished at the turn of the nineteenth century when Simmons built himself a substantial house on the site, which he occupied from 1802 to 1807.

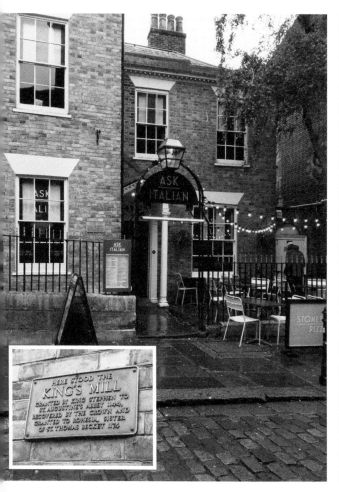

Above left: This building on the King's Bridge sits on the site of the King's Mill.

Inset above left: Stone to mark the site of the King's Mill.

Above right: View along the Stour from the King's Bridge.

King's School

King's Canterbury is thought to have developed from a school founded by Saint Augustine in 597 and it is, therefore, regarded as the oldest known teaching establishment in the world. Although there is little information about Augustine's original abbey school, by the twelfth century there is clear documentary evidence of the existence of a cathedral school and it is this establishment that was to flourish in the wake of Henry VIII's Church reforms.

Following the Dissolution of the Monasteries, the school was refounded in 1541 by royal charter and was thereafter known as the 'King's School'. In the century following its revival, the school was to reach new heights of academic achievement and establish an impeccable national reputation – largely thanks to the first headmaster, John Twyne, and the generosity of its benefactor, Cardinal Pole.

The Victorian King's became a 'public school' under the terms of the 1868 Public Schools Act and its premises underwent significant changes during the mid-nineteenth century. Later generations have seen continued development of the school, from the improvement and expansion under headmaster Canon John Shirley in the 1930s to the admission of female pupils in the 1970s.

Old King's scholars include Christopher Marlowe, John Tradescant and William Harvey whilst modern alumni include Field Marshall Montgomery, Patrick Leigh Fermor, Michael Morpurgo, Harry Christophers and Fran Houghton.

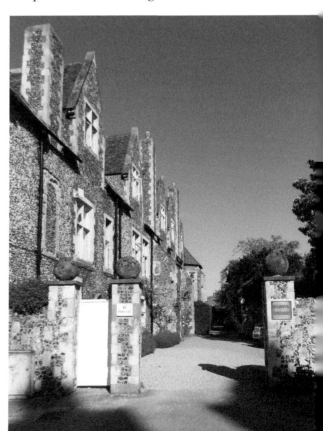

The King's School.

L

Lady Wootton's Green

This quiet enclave along the busy city ring road is the last vestige of the fields that once lay between St Martin's Church, St Augustine's Abbey and the cathedral and would have formed part of the route used by Queen Bertha as she travelled out, through the Queningate in the city wall, to worship at her private chapel – the same route as travelled by funerary processions of kings and archbishops laid to rest at the abbey.

When the Woottons arrived in 1612, it was to take up tenancy of the dissolved abbey, where Lady Wootton would live until her death in the late 1650s. The area was transformed into public gardens for the enjoyment of the city in 1896 and, prior to the war, the green was surrounded by medieval buildings; however, these were largely destroyed during 1942 and only the almonry retains its thirteenth-century ground floor. The statues of King Ethelbert and Queen Bertha – by Stephen Melton – were erected in 2006 and installed here in recognition of the couple's steadfast support for the Christian faith and the parts they played in promoting the religion in these islands.

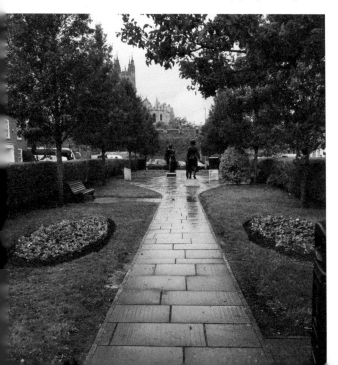

Lady Wootton's Green.

Lanfranc (*c.* 1010–89)

Lanfranc was a renowned scholar and churchman at the forefront of Norman politics when he was brought to England by Duke William and consecrated as Canterbury's archbishop in August 1070. Upon his appointment, he immediately began to implement sweeping Church reforms and systematically replaced English Church officials with Norman candidates in a concerted effort to bring the English church firmly within the control of the new Anglo-Norman administration. Such was his position within the new royal regime that Lanfranc sometimes acted as vicegerent for the king during his periods of absence from England. However, despite his support for William and the significant role he played in the politics of his day, Lanfranc also strove to maintain the Church's independence from State affairs and to reinvigorate English monasticism.

Stephen Langton (*c.* 1150–1228)

Cardinal Langton was instrumental in the creation of Magna Carta in 1215. Educated at the University of Paris (where he also lectured in Theology), he was considered the foremost churchman of his generation. However, his election (engineered by the Pope) in 1207, to the Archbishopric of Canterbury, was controversial and strongly opposed by King John, who declared that any Englishman who recognised Langton as archbishop was a public enemy; the Pope responded by placing John's entire kingdom under interdict for four years. As a consequence of the feud between King and Pope, Stephen did not take up residence at Canterbury until six years after his appointment and, on his return to England, opposed John in support of the political independence of the English barons. A prolific writer, it is believed that, as well as composing numerous original treatises and commentaries, Langton was responsible for the now standard division of the Bible into chapters and verses.

Langton's burial is unusual: originally laid in open ground outside the cathedral, his tomb was built over with the construction of the St Michael Chapel in the 1430s and now stretches across the wall, with the head inside the chapel at its altar and the foot projecting out through the south wall.

Stephen Langton's tomb crosses the south wall of the cathedral; the head end is within the St Michael's Chapel but the foot is outside. (Photographs Canon Ian Black)

Longmarket

This area suffered virtually complete destruction during the fire-bomb raids of the Second World War and long gone are the massive Corn Exchange and long market itself, which occupied the site from 1825. However, evidence of a deeper history has been uncovered through pioneering archaeological investigations: a significant area of Roman mosaic pavement was discovered (now a Scheduled Ancient Monument) and five Anglo-Saxon structures were also excavated, revealing a quantity of loom weights and domestic paraphernalia such as bone combs, beads and keys. A mysterious skeleton was also unearthed – apparently a medieval murder victim...

The rent rolls pertaining to the area (and still held by the Cathedral Archives) give an idea of its affluence: Theoric the Goldsmith, a king's agent for both Richard and John, lived here at the turn of the thirteenth century, his large property portfolio reaching over into Butchery Lane and Burgate. Thousands of pottery sherds, originating from as far afield as North Africa and the Middle East, have been recovered from rubbish pits across the site, each exotic fragment attesting to the luxury enjoyed by Longmarket's inhabitants.

Below left and right: Longmarket.

M

Marlowe

Born the son of a Canterbury shoemaker in 1564, Marlowe was a gifted pupil at the local King's School, and won a coveted scholarship to Corpus Christi, Cambridge. Although few facts about Marlowe's life have come down through history, speculation about his possible involvement in Elizabethan espionage has endured: his time at Cambridge was punctuated by long, unexplained absences and accounts show him to have been in possession of a considerable income, far exceeding his scholarship funds. Suspicions about Marlowe's religious preferences caused some hesitation in the awarding of his Master's degree in 1587; however, the college was convinced by the word of the Privy Council that Kit was to be commended for his 'good service' to the Queen and 'faithful dealing' on her behalf in 'matters touching the benefit of his country'. He certainly had a sketchy reputation and was arrested on a number of occasions for brawling, violence and counterfeiting coins and he spent a fortnight in Newgate Jail after being involved in a fatal altercation. Possibly employed by Francis Walsingham, or tutor to Arbella Stuart, no definitive proof of Marlowe's occupation has yet come to light.

Marlowe's work was original, adventurous and was to have a long and deep influence on English literature for centuries after his lifetime. One of the pioneers of blank verse, Marlowe revolutionised the Elizabethan theatre and enjoyed huge success during his short career.

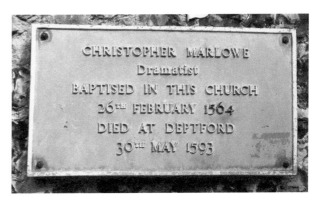

Plaque to commemorate the baptism of Christopher Marlowe at St George's Church, Canterbury, in 1564.

On 30 May 1593, Marlowe was suddenly reported dead – purportedly stabbed by Ingram Frizer in a fight. The coroner's report on the death (which was only rediscovered in the 1920s) describes a simple fracas and act of self-defence by Frizer, yet there are many holes in the story and the mystery of Kit Marlowe refuses to rest easy.

Marlowe Theatre and Marlowe's Muse

The Friars Cinema, built in 1933, was converted to the Marlowe Theatre in 1984 after the demolition of the theatre's original St Margaret's Street site. Further redevelopment in 2009 saw the emergence of the New Marlowe Theatre, designed by architect Keith Williams and opened in 2011. The new building also houses the Marlowe Studio and a satellite location, The Marlowe Kit, opened in Stour Street in 2018 (*see* Poor Priests' Hospital).

The Marlowe Memorial Committee was established in 1888, in the belief that Marlowe's enormous talent and contribution to English literature had been overshadowed by his reputation as an atheist. A public fundraising campaign, supported by Ellen Terry and Henry Irving, raised £100 towards the cost and the memorial was commissioned from sculptor Edward Onslow Ford in 1891. A bronze statue, *The Muse of Poetry*, and four statuettes of actors portraying some of Marlowe's characters make up the piece, which stands, today, outside the Marlowe Theatre in The Friars.

Marlowe Theatre.

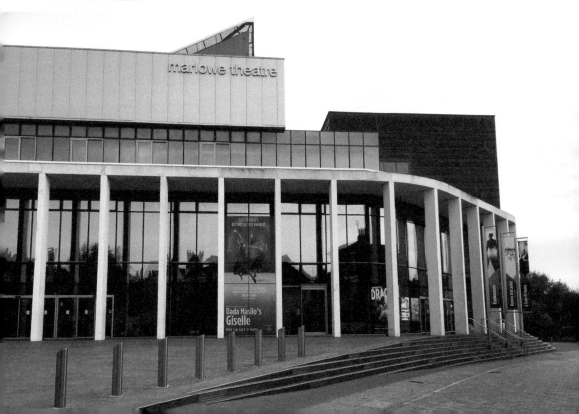

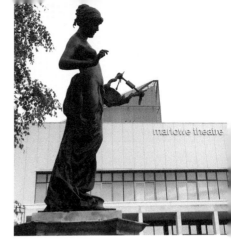

Marlowe's Muse by Edward Onslow Ford.

St Martin's Church

Founded before the arrival of Saint Augustine in Canterbury in the sixth century, this church is the oldest parish church in the country and, indeed, in the English-speaking world and forms part of the World Heritage Site that also comprises Canterbury Cathedral and St Augustine's Abbey. St Martin's was the church adopted by Queen Bertha, the Christian Frankish princess married to the Kentish King, for her own use as a private chapel before the general conversion of Kent to the Christian faith. It was this church that provided Saint Augustine with a base from which to launch his mission for the conversion of England and it was here, allegedly, that he baptised King Aethelberht at Christmas, 597.

Bertha brought from France her chaplain, Luidhard, and a gold Anglo-Saxon coin bearing his legend – known as the Luidhard Medalet – was discovered at the church in the early 1800s. This small piece was one of the eight items discovered in the Canterbury-St Martin's Hoard and is believed to be the earliest surviving Anglo-Saxon coin. It was likely struck at the Canterbury mint; however, it was probably made as a pendant (a hanging loop is attached) as a symbol of the wearer's Christian conversion, rather than to be used as currency. It is generally accepted that the hoard was buried as a necklace, probably during the 570s–80s, in the grave of a woman laid to rest at the church. With the exception of one piece, the hoard is currently held at the World Museum in Liverpool.

Dedicated to St Martin of Tours – a local saint to the French-born Bertha – this little Saxon chapel was built on the site of a Roman tomb or mortuary chapel and there is Roman masonry and brickwork in its fabric. The ghost of the Saxon edifice can still be seen in the small windows and blocked doorways, whilst the post-Conquest improvements and enlargements are evident from the inclusion of large Caen stone blocks and a finely worked pillar font, believed to have been transferred from the cathedral. The city's great and good have been buried in the church's graveyard for centuries and include artists Sydney Cooper and Mary Tourtel; local historian and builder Walter Cozens; and local Member of Parliament, King's Counsel and Speaker of the House of Commons Sir John Finch.

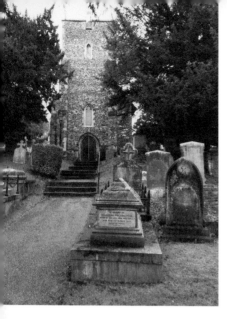

St Martin's Church, the oldest Christian church in the English-speaking world.

Martyrs

The Reformation in England was a brutal and bloody battle for religious supremacy and its casualties were numerous. The Catholic reign of Mary Tudor (1553–58) saw the executions of over 250 so-called 'Maryan Martyrs', persecuted and condemned for their Protestant faith. 'The Canterbury Martyrs' is a name given to a group of around forty of these men and women from across Kent (including two clergymen) who were arrested and executed for heresy between 1555 and 1558. In his 1563 book *Acts and Monuments* (commonly known as the *Book of Martyrs*), John Foxe describes how the Canterbury victims 'resigned themselves with Christian fortitude, fervently praying that God would receive them into his heavenly kingdom'.

Burned at the stake, the Canterbury Martyrs suffered an horrific fate, which was documented and illustrated in Foxe's publication. The site of their executions, along Martyr's Field Road in Wincheap, is marked by a stone memorial cross and small public garden.

When Elizabeth I succeeded her sister in 1558, the country saw a rapid return to the Reformist principles of her brother, Edward, and so began a new era of Protestant rule, bolstered by Catholic subjugation. The Oaten Hill Martyrs were executed at a time when Elizabeth's government perceived the Catholic threat to their monarch's safety to be at its height: the Anglo-Spanish war had reached a crescendo in the summer of 1588 with the attempted invasion by Phillip II's armada. Supported by the papacy, it was feared that Phillip and his Inquisition would stop at nothing in their quest to turn England again towards Rome – and every Catholic in England was regarded as a potential spy and would-be assassin...

None of the men hanged at Canterbury in 1588 were residents of the city: the three Catholic priests – Robert Wilcox from Chester, Gerard Edwards from Ludlow, and Christopher Buxton from Derbyshire – had all trained at the Catholic seminary in

The Martyrs' Memorial in Martyrs' Field Road, on the outskirts of the city.

Rheims and Robert Widmerpool was a Nottinghamshire-born tutor employed in the household of the Countess of Northumberland. When arrested, all were sent to the Marshalsea Prison and taken, later, to Oaten Hill, where they suffered the agonies of being hanged, drawn and quartered on 1 October. In 1929, all four were beatified by Pope Pius XI.

St Mary's Church

A church dedicated to St Mary had been incorporated into the Northgate from around 1300. This was refurbished in the 1770s and, when that gate was destroyed in the 1830s, a new church building was erected in the fashionable Egyptian style. A sunken garden now gives a perfect viewing platform for the early wall remains at this site, including a section of original Roman wall. Deconsecrated in 1912, the church building now belongs to the King's School.

St Mildred's Church

St Mildred, who lived during the seventh and early eighth centuries, was a descendant of Kent's first Christian king, Aethelberht, and, through his wife, Bertha, of the Frankish kings. She was possibly educated at the Merovingian royal Abbey of Chelles and, after her mother, Domne Eafe (St Eormenburga) established the abbey at Minster-in-Thanet, Mildred was appointed to the position, there, of abbess. Arriving at Thanet some time before 694, Mildred would spend the remainder of her life there and was buried in the abbey when she died in the 730s. However, after the Danish sack of Kent in the early eleventh century, a decision was made – against the wishes of the Minster-in-Thanet

locals – to remove the relics of St Mildred and have them laid, instead, at St Augustine's in Canterbury in 1030. Another set of relics, believed to have been those of St Mildred and her sister, St Milgitha, was hidden during the Viking raids and given to St Gregory's Priory by Archbishop Lanfranc in 1085. To bring the story full circle, a group of Benedictine nuns purchased the abbey at Minster in 1937 and received a relic of St Mildred in 1953.

St Mildred's Church is the only pre-Conquest church within the city walls and one of only a handful surviving in the county. Although no definitive date for the church's construction can be given, it is generally accepted that its foundation might have coincided with the translation of St Mildred's relics in 1033 and a small depiction of the saint is featured in one of the west chapel windows. The original church, a large Saxon edifice with walls constructed from reused Roman masonry, was devastated by fire in the mid-1200s but rebuilt, expanded and improved repeatedly throughout the following centuries. The south-east chapel, built from flint and stone in Tudor chequers, was created in 1512 by Sir Thomas Atwood, who was Mayor of Canterbury. Much of the stained glass now in situ was commissioned from prominent glass artists of the day such as Charles Kempe and Burlison and Grylls.

St Mildred's Church, its Tudor-chequered south-east chapel clearly visible.

St Mildred's Church.

N

St Nicholas Chapel Leper Hospital

Leprosy was endemic in England at the time of the Norman Conquest and Archbishop Lanfranc founded this hospital in the early 1080s for the care of victims of the disease. St Nicholas' Hospital was probably the first of its kind in England but there were soon to be similar institutions all over, often built – like this one – on the outskirts of towns to allow their inhabitants the opportunity to beg alms from the more fortunate citizens within the city walls. Gradually, cases of the disease began to diminish and those hospitals which did not succumb to ruin through neglect were put to other uses: during the 1500s, St Nicholas' underwent significant refurbishment and extension (and was to be rebuilt again, in the 1840s) and entered a new phase of occupation as an almshouse for the destitute. In the 1930s, the independent parish of St Nicholas was combined with neighbouring St Michael's; however, this institution's tradition of care continues to this day as the hospital now provides retirement housing, whilst the church continues to support the victims of leprosy through links with a mission in Tanzania.

Northgate

The gate itself is long gone, but a Cozens stone* marks its situation and Northgate Street – the route towards the Kent coast – is the thoroughfare by which kings would

Remains of the medieval wall at Northgate.

enter and St Alphege would have been taken from the city. Like some of the other city gates, Northgate incorporated a church, St Mary's, after 1300, which was rebuilt in the Georgian period after the gate itself was demolished. A section of the original Roman city wall which once formed a part of St Mary's Church can be seen at one end of the sunken garden in St Radigund's Street.

Nun of Kent

Elizabeth Barton, alternatively known as the 'Mad Maid of Kent' and the 'Holy Maid of Kent' was born into a poor family in a village just outside Canterbury at the start of the sixteenth century. In 1525, during a sudden bout of illness, the teenaged Elizabeth began to make claims that she was receiving visitations from the Virgin Mary and urged people to remain faithful to the Catholic Church and to demonstrate that faith by undertaking pilgrimages. She also made prophecies, some of which appeared to be fulfilled and this, it seems, was proof enough to convince Archbishop William Warham and Bishop John Fisher of Elizabeth's credibility. However, as her fame spread, so did concern for Elizabeth's spiritual well-being and she was moved into the Canterbury nunnery of St Sepulchre, where she took Holy Orders. Such was Elizabeth's fame and the regard in which she was held that she was granted private audiences with Cardinal Wolsey and Thomas More and twice met Henry VIII, who saw the charismatic young woman as a valuable ally in his mission to hold back the tide of Lutheranism and maintain order in his kingdom. However, as Henry's Great Matter began to gather pace, so Elizabeth began to speak against the sovereign, warning Henry to take back Catherine and renounce his claims to the English Church – he would die soon, she prophesied, and she had seen the place in Hell where Henry would burn for eternity...

As Elizabeth's proclamations began to work against the king, so his agents began the process of destroying her good character and reputation: rumours of mental instability and sexual transgression were circulated widely and, when she was arrested in 1533, Cromwell recorded that Elizabeth admitted her guilt – but perhaps it is worth noting that his is the only evidence there is for Elizabeth's alleged confession. As her crime was deemed treasonous, Elizabeth was hanged at Tyburn, along with five men who had remained her loyal followers.

After her execution, Elizabeth's body was interred at Greyfriars, Newgate, but, in one final act of contempt, her accusers mounted her head on a spike on London Bridge– she is believed to be the only woman known to have suffered this degradation.

O

Opus Alexandrinum

The spectacular mosaic pavement of the Trinity Chapel at Canterbury Cathedral is worked in tessellated Italian marble. Although the pavement was laid here as a ground for the glittering tomb of Thomas Becket in 1220, it is possible that at least some of the stones were removed from other areas of the cathedral. Named for the Emperor Severus Alexander, the stonework technique showcased here is highly skilled artistry and extremely expensive to commission: this example is regarded as one of the most impressive of its kind in the country.

The design is mysterious: the central pavement mosaic is surrounded by circular carvings of zodiacal symbols; the monthly labours; the seven virtues and vices; and strange, mythological creatures. The provenance of the outer sections of the pavement is unknown but some of the roundels are worked in the same pink marble that it is believed was used to fashion Becket's tomb itself.

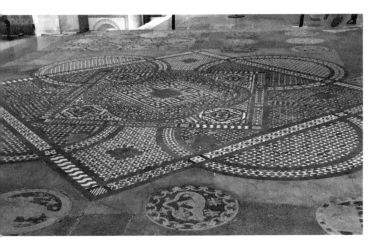

Above left: Opus Alexandrinum – the spectacular marble pavement of the cathedral's Trinity Chapel.

Above right: The pavement's mysterious design includes signs of the zodiac such as this representation of Aquarius.

A solitary candle now appears to be the only marker for the site of the long-lost tomb but, on careful inspection of the pavement, a distinct depression can be discerned in the marble, circling the empty space where the tomb once stood – an echo of the thousands of penitent feet and knees bent in prayer that have gone before.

No. 28 Palace Street

Possibly the most photographed building in Canterbury after the cathedral, the 'crooked house' at the corner of Palace and King's Street was once the premises of the Old King's School Shop and serves, today, as a bookshop but was probably originally used as a weavers' workshop when it was constructed (probably in 1617). One of the house's interesting features is a supporting bracket carved in the image of a Native American, suggesting early ties between this corner of Canterbury and the New World.

The remarkable lean of this three-and-a-half storey house, caused by structural alterations to a chimney stack, resulted in a catastrophic collapse in 1988. However, the City Council and the Canterbury Archaeological Trust secured its restoration and, despite its alarming appearance, the entire building is now supported by a steel frame to prevent further shift.

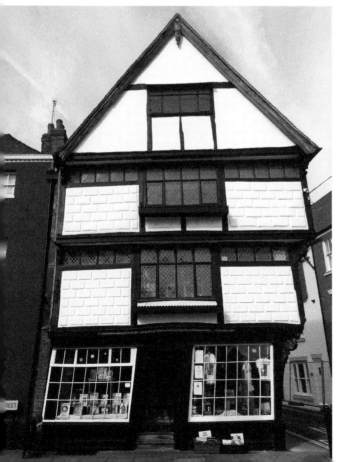

No. 28 Palace Street, Canterbury's celebrated 'crooked house'.

P

Pilgrimage Site

The cult of saints, relics and pilgrimage became increasingly popular throughout the great monastic revival of the tenth century and was especially prevalent between 1100 and 1500, at which time the full force of the Reformation began to gather pace. In Canterbury, the shrine of Thomas Becket, that famous archbishop savagely murdered in cold blood at the very heart of the cathedral, was to become a pilgrimage site of unimaginable wealth and status whilst it stood in the Trinity Chapel between 1220 and 1538.

Chaucer's pilgrims, thrown together by chance as they travelled the Canterbury road, are all heading, for one reason or another, to that very shrine and they would have expected to meet a thronging mass of like-minded fellows upon their arrival at the

Above: Pilgrims would trace the outline of their footprint to show that they had completed their journey as they waited to visit the martyrdom and shrine of Thomas Becket.

Right: The well-worn steps leading to the shrine of Thomas Becket echo with the footsteps of generations of devotees.

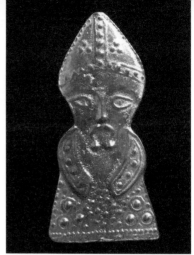

Above: Pilgrims collected badges or tokens to prove that they had completed a pilgrimage. Representations of Thomas Becket, like this modern replica piece, were very popular.

Left: The stone pavement around the shrine site has been similarly worn away.

city gates. Nor would they have been in low company; across Europe, monarchs and magnates were known to undertake pilgrimages (to Rome or Santiago de Compostela in particular) and, indeed, Henry II, in penitence for the crime of Becket's brutal killing (for which he publicly blamed himself) made a pilgrimage of his own to the tomb – barefoot and dressed in a hair shirt.

Whether seeking a blessing, atonement for sins, the cure for an illness or perhaps simply expressing the depth of their own faith and devotion, the reasons for making a pilgrimage were as numerous and diverse as the pilgrims themselves. However, one aspect of pilgrimage was common to all: the tribute paid to the saint at the journey's end. Many pilgrims would also buy a souvenir badge or pin as proof that they had made the arduous trip. At Canterbury, these tributes amassed huge wealth for the cathedral: when Henry VIII's men came to dismantle the shrine in 1538, it took them ten days to do so and they removed two huge chests of gold and over twenty cartloads of jewels. The traffic of pilgrims has left its mark on Canterbury: the well-worn stone steps and cloister ledges inscribed with the outlines of pilgrims' soles – proof of the completion of their journey – attest to the power of Becket's cult here.

Poor Priests' Hospital

On this site, in 1220, a substantial residence which had formerly served as a tannery was converted into an almshouse for the accommodation of impoverished priests.

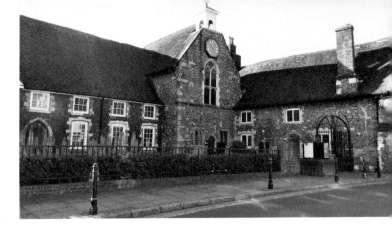

The Poor Priests' Hospital.

As the needs of the establishment increased, it was granted the support of several churches surrounding the town and extensive improvements were made to the fabric of the building, including the addition of a solar and undercroft for the use of the housemaster. Later, a chapel and new kitchen block were added.

Having survived the Dissolution, the hospital was surrendered to the Crown in the 1570s, the building being granted to the city to serve as the municipal poorhouse during the reign of Elizabeth I. For many years, it also served as the 'Bridewell' or prison but, in 1727, it was converted into a workhouse in accordance with the Canterbury Poor Relief Act and its inmates were tasked with weaving hop sacks, knitting and sewing among other duties. From this time, the 'house of correction' also functioned as a school for poor boys until, in 1823, the Museum of Canterbury (later the Canterbury Heritage Museum) was established here by renowned local botanist William Masters. Although the museum closed its doors in 2018, the building has since been reopened as The Marlowe Kit, a satellite site of the Marlowe Theatre, escape room and exhibition space.

Pound Lane Prison

The prison was built in the 1820s when accommodation within the adjacent Westgate Towers jail finally became inadequate and it was converted into the police station in the 1860s. It served the city in this capacity for a century but was sold to the East Kent Music School in 1965. In the early 2000s, the prison building was refurbished along with the Westgate Towers and the site reopened as a museum and events venue.

Pound Lane Prison – now a museum and events venue.

Queen Elizabeth's Guest Chamber

When the Virgin Queen turned forty, it is said that she chose to spend the occasion here, at what was then known as The Crown Inn. Throughout its long history, which dates from the beginning of the eleventh century, this building has accommodated

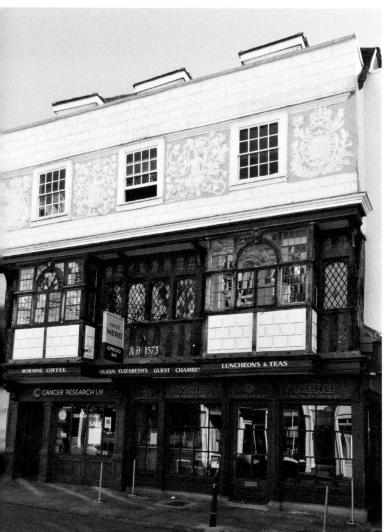

Queen Elizabeth's
Guest Chamber.

numerous shops, bars and cafés and it has been repeatedly expanded, extended and improved; for example, the elaborate plasterwork on the top storey was added in 1663 and the dormer windows above in the 1700s. The yard behind was the site of the nineteenth-century Drury & Biggleston Iron Foundry and the city's first police station was also situated here in the 1830s.

Queningate

The ghost of the long-blocked Queningate can just be discerned in the city wall along a stretch now used as public car-parking. A small, curving section of red brick delineates the outline of an arched opening, in-filled with Roman and medieval masonry. A charter of 762 explains the gate's name as a reference to its use by Queen Bertha on her daily progress between the cathedral and the church of St Martin and, today, a marked pedestrian route traces that same journey through the city's streets.

The former Queningate, through which Queen Bertha is believed to have crossed the wall each day. A fragment of red-brick arch can just be seen within the infill.

Roman Ruins

The Canterbury of the Roman Empire was dominated by a massive theatre, possibly linked to an ancient temple complex, which was developed and augmented through the second and third centuries. Twentieth-century excavations revealed the astonishing scale of the theatre premises – stretching from Castle Street through Watling Street into St Margaret's Street in a D-shaped curve, measuring 75 by 57 metres and possibly rising to 25 metres in height. Archaeological findings suggest that the dominance of the building might have continued well into the Anglo-Saxon period as road coverings from this time indicate that building was being undertaken in consideration of the huge Roman edifice.

Further along St Margaret's Street are the remains of the hypocaust system of a public baths complex and across the city, in Butchery Lane, there are the remains of a wealthy town house with beautifully detailed mosaics, giving some indication of the luxurious lifestyle enjoyed by some of Canterbury's Roman-era residents.

Roman masonry has been found throughout city, reused and repurposed; for example, in the building of the cathedral's crypt and, later, its great tower.

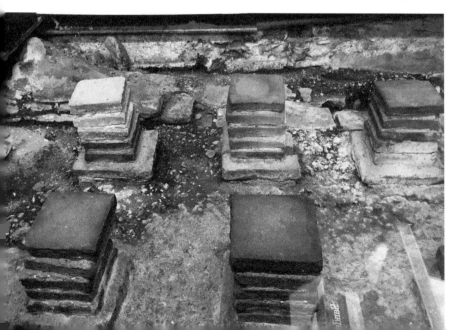

The remains of a Roman hypocaust system beneath one of the shops in St Margaret's Street.

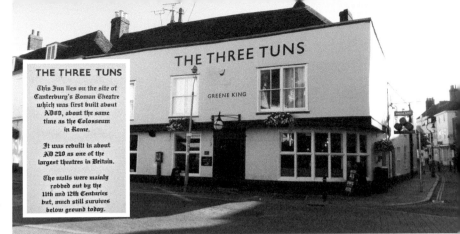

The Three Tuns stands on the site once occupied by a large Roman theatre.

Roper Gate

This magnificent gateway in St Dunstan's Street is all the remaining evidence of a grand Tudor dwelling, once home to the Roper family, who owned the Canterbury manor of St Dunstan. Built in the 'English bond' style from small, dark-red Tudor bricks, the original gate can be dated to the early sixteenth-century but it has undergone considerable repair and refurbishment over the years. Its elaborate and highly decorative style marks this gate as an excellent example of Tudor brickwork and also gives some indication of the status of the Roper family for whom it was constructed.

Margaret Roper, daughter of Sir Thomas More, was a renowned scholar and linguist regarded as one of the sixteenth-century's most well-educated individuals. Margaret married William Roper in 1521 and the couple lived, mainly, at Eltham until Margaret's death in 1544, just nine years after her father's execution. She was buried at Chelsea Parish Church but was reinterred with her devoted husband after his death, in 1577, in the Roper family vault at St Dunstan's Church.

The Roper Gate, last vestige of the Canterbury home of Margaret Roper, daughter of Sir Thomas More.

St Sepulchre's Nunnery

A priory for Benedictine nuns is recorded as having been founded by Archbishop Anselm, with an endowment from William Calwell, at the end of the eleventh century. Hamo, son of Vitalis, the Norman knight identified in the Bayeux Tapestry, is said to have persuaded Anselm to support a small group of 'black' – or Benedictine – nuns tending a chapel built on a Roman graveyard. The priory's dedication, in honour of the church of the Holy Sepulchre in Jerusalem, reflects the crusading-fever of the era. In 1284, injunctions were issued against the Priory of St Sepulchre by Archbishop Peckham, with references being made to the poor discipline and 'quarrelsome' nature of its sisters.[1] Complaints are levelled at the negligence of the prioress and objections are made to the nuns' casual interactions with men of the town, including a specific accusation against Isabel de Scorue and an unnamed cellarer of Christchurch. Almost a century later, things had not improved and Prioress Joan Chiltern was removed from office in 1368. However, these offences pale into insignificance when compared with the scandal brought upon the house by its association with Elizabeth Barton, the so-called 'Nun of Kent' in 1534 (*see* Nun of Kent). When the nunnery was dissolved in 1537, its possessions were leased to Robert Darkenall of Canterbury. The site of the nunnery, along the Old Dover Road, is commemorated in the local street names Nunnery Road, Nunnery Fields and Chantry Lane.

Simmons, James (1741–1807)

Born to a local family, Simmons was a King's School scholar who became a philanthropist and politician and founded the *Kentish Gazette* in 1768. Having served his apprenticeship as a stationer, Simmons returned to Canterbury to set up a business in the town as a stationer and newspaper seller. The enterprise also extended to printing, publishing and bookbinding (including first editions of Hasted's works) and managed a circulating library. A keen proponent of modernisation and improvement of the city he called home, Simmons was responsible for the creation of the Dane John Gardens as a pleasure park for the people of the city (a project he

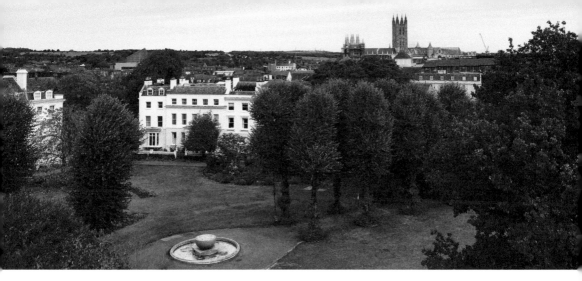

Above: View from the mound over James Simmons' Dane John Gardens.

Right: Blue plaque in the High Street to Alderman James Simmons, one of Canterbury's great benefactors.

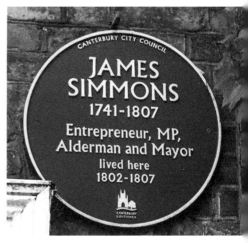

funded himself). He co-founded the Canterbury Bank in 1788 and he was one of the key supporters of the Pavement Commission, established in the late 1780s 'for the better paving, cleansing, lighting and watching of Canterbury'. In 1803, the King's Mill was refurbished as a home for Simmons and he lived there until his death in 1807.

Somner, William (1598–1669)

Canterbury-born Somner is probably best known as an antiquarian and he conducted a survey of the city, published in 1640, entitled, *The Antiquities of Canterbury; or a Survey of that ancient Citie, with the Suburbs and Cathedral.* Engaged as court registrar for Archbishop Laud, Somner was later appointed master of the St John's Hospital and auditor of Christchurch; however, his association with Laud did not serve Somner well after Laud's execution for treason in 1645. Amid the horror of the English Civil War, William had been witness to the destruction of the Canterbury Cathedral font in 1642: he collected and hid the broken pieces, presenting them to the new King Charles

No. 5 Castle Street, birthplace of William Somner.

in 1660. Somner's own interests lay deeply rooted in historical enquiry and in the Anglo-Saxon period in particular. In 1657, he was awarded the Spelman stipend, which enabled him to research and publish his *Dictionarium-Savoico-Latimo-Anglicano*, which was to become a standard text at Oxford University for generations. Somner is buried at St Margaret's Church.

Stour River

The Great Stour River runs from its source near Lenham right through the heart of Canterbury and on, through Kent, until reaching the Strait of Dover at Pegwell Bay. Although its modern name comes to us from the Saxon (meaning 'stirring'

Below left: The Great Stour as it flows towards the city's Westgate Towers.

Below right: View along the Stour.

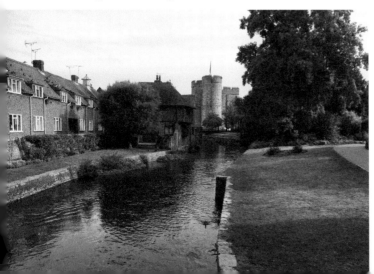

or 'moving'), this waterway has been central to the development of the city from its earliest settlement: Neolithic long barrows located along the river just outside Canterbury – Julieberrie's Grave, Shrub's Wood Long Barrow and Jacket's Field Long Barrow – testify to the presence of a pastoralist farming community from the Early Neolithic (*c.* 4500–3800 BCE) onwards. Having served its community's farmers, builders, weavers, tanners and printers for millennia, the Stour now offers opportunities for picturesque river tours through the city centre.

Sudbury, Simon (*c.* 1316–81)

Sudbury rose to prominence at the court of King Edward III, having been educated at the University of Paris, and served as papal chaplain to Innocent VI. Elevated to the archbishopric in 1375, Sudbury was charged with the coronation of the young King Richard II two years later. As Lord Chancellor, Sudbury was regarded as responsible for the loathed Third Poll Tax, which triggered the Peasants' Revolt of 1381: his properties at Canterbury and Lambeth were violently attacked before the mob stormed the Tower of London and dragged the archbishop to his death at Tower Hill. It was reported that it took eight strokes of the axe to sever Sudbury's head form his neck. Although his remains were interred at Canterbury Cathedral, his head was returned to his own parish church of St Gregory in Sudbury, Suffolk.

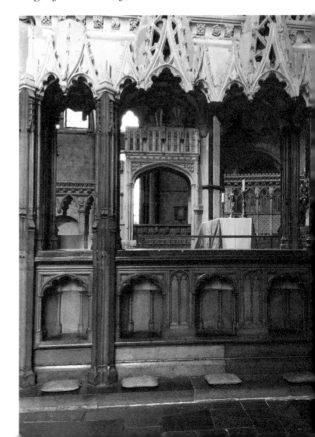

The Sudbury tomb at Canterbury Cathedral with its 'whispering chambers', specially designed to ensure complete privacy in prayer.

Tannery

The Williamson family tannery was founded in the 1790s and largely built on the demands for army kit during the Napoleonic Wars. As it expanded, the business occupied a number of sites across the city and contracts to supply upholstery leather to luxury car manufacturers ensured continuing success into the twentieth century.

Steve Porthmouth's sculpture the *Canterbury Bull* in Tannery Field commemorates the industry of the city's tannery across the road.

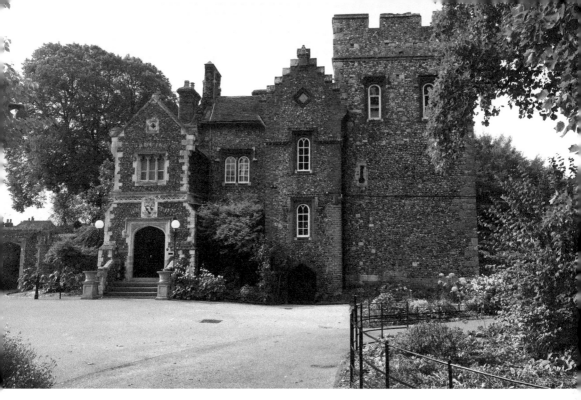

Tower House, home to Stephen and Catherine Williamson.

In 1936, Stephen Williamson and his wife, Catherine (who was Canterbury's first female mayor), made a generous gift to the city of their home: Tower House and Westgate Gardens.

The St Mildred's tannery site (which is now a large housing development) stretched across the modern Rheims Way road and down towards the River Stour. Since the closure of the works in 2002, this area has undergone a major redevelopment and now forms part of the Westgate Parks. Steve Portchmouth's sculpture *The Canterbury Bull* was created from the tracks of the disused Tannery Railway and installed in the Westgate Parks' wildflower meadow, in the Tannery Field, in 2016 as a tribute to the area's heritage.

Tourtel, Mary (1874–1948)

Mary Caldwell was born, lived and died in Canterbury. Having studied under Thomas Sydney Cooper, she became a book illustrator and created Rupert Bear in 1920. Mary's husband, Henry Tourtel, who was editor of the *Daily Express*, commissioned his wife to produce a cartoon to compete with the popular series featured in both the *Daily Mail* and the *Daily Mirror*. Mary's original *Little Lost Bear* was brown and furry and, although he wore grey trousers with a blue jumper, bore far more resemblance to a real bear than he did to the modern Rupert with which we are familiar today. Mary and her husband are both buried at St Martin's Church.

Universities

After almost two decades of discussion, the University of Kent at Canterbury was founded in 1965. One of the original seven 'Plateglass Universities', it now ranks within the UK's top fifty, according to *The Complete University Guide* (2020).[1] In its first year, 500 students were welcomed into its four original colleges. Today, the number of students has reached around 20,000, and there is fierce competition for places every year. A further two colleges have been added at the Canterbury site, as well as satellite campuses at Medway, Tonbridge and Brussels, and post-graduate centres in Paris, Rome and Athens, making Kent 'the UK's European university'.

Canterbury Christ Church University originated as a Church of England teacher training college in 1962. Established as a response to the national teacher shortage crisis, its first cohort of students numbered just seventy. Continuous development and expansion saw the introduction of the Bachelor of Education degree in 1968, followed by non-teaching degrees in the late 1970s and the acquisition of several satellite sites across Tunbridge Wells, Broadstairs and Medway. In 2005, the university college was awarded independent university status and is now home to around 15,000 students.

The University of Creative Arts emerged as a university college in 2005 but was awarded full university status three years later. The institution, which began life as the Sydney Cooper School of Art in 1868, now caters for over 7,500 students and is associated with similar small, independent art schools across the county and, indeed, the globe. As of 2020, it is the only creative arts university to rank within the top thirty in the Times Higher Education Table of Tables.

V

Vikings

The force of the Viking arrival in Kent was described in the *Anglo-Saxon Chronicle* for 851. It tells us that, in that year, there 'came three hundred and fifty ships to the mouth of the Thames, and stormed Canterbury'.[1] Fifteen years later, it records that 'a heathen host' laid waste to the eastern parts of Kent in a treacherous night-time raid. Over the next century, the Danes had overrun the greater part of England south of East Anglia and (according to the Laud Chronicler) 'went about everywhere in bands, and robbed and slew our unhappy people'.[2] In September 1011, they laid siege to Canterbury, having already ransacked the minster at Thanet and whilst threatening an attack on London. They took hostages for ransom including Archbishop Alphege and 'all those in holy orders ... then they went to their ships, taking the archbishop with them... And they kept [him] prisoner until the time when they martyred him'.[3]

On returning to their camp at Greenwich, they demanded a huge ransom for Alphege, but the archbishop forbade the people of Canterbury to pay. In vengeance, the incensed Vikings 'pelted him to death with bones and the heads of cattle'[4] and so Alphege became England's first martyred archbishop. Cnut oversaw the removal of Alphege's remains to Canterbury in June of 1023 and the story of the siege and martyrdom is depicted in stained glass in the north choir aisle at the cathedral.

St Alphege's Church in Palace Street was already established when Lanfranc undertook to rebuild it in 1070. In later life, it served as the Walloon and Huguenot weavers' chapel and it has links with the United States due to its having been the church at which Robert Cushman was married to his first wife, Sarah Reder, in 1606.

St Alphege's Church, dedicated to the martyred archbishop, within the shadow of the cathedral tower.

Walls

The Roman wall surrounding the city centre was constructed around 270–80, a huge, defensive stone structure built on a raised bank and fortified further by a deep ditch. The ring of this original edifice was punctuated by five gates, leading to the five major roads connecting Canterbury to the rest of England and, from Dover, to the Continent. At the start of the occupation, when the Roman Empire was thriving and unassailable, little thought was given to municipal defences but, by the end of the third century, security had become a serious concern and Canterbury, at the convergence point of the roads from all the Saxon Shore forts – at Lympne, Dover, Richborough and Reculver – became strategically significant.

After the collapse of the empire, the Roman fortifications fell into disrepair and remained partially ruined until a comprehensive rebuilding programme was undertaken at the end of the fourteenth century when, again, fears of foreign invasion sparked renewed demands for protection: the new wall – in part, the work of the favourite architect of the court, Henry Yvele – incorporated surviving sections of its Roman ancestor but now boasted twenty-four towers designed to hold gun batteries. From 1378, collection of murage – a tax levied on town trade specifically to raise

Below left: A section of the flint and ragstone city wall circuit.

Below right: Inside one of the wall's defensive gun ports.

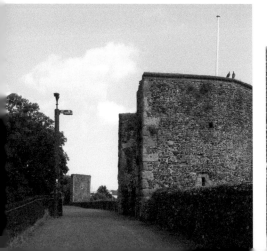

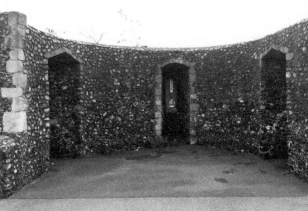

revenue for the project – covered the enormous costs incurred; from the early 1400s, the tax was reconfigured into a system of rates collected to pay for the maintenance of the new wall.

Today, roughly half the medieval wall circuit remains intact and it is regarded as an excellent example of its type.

War Horse

Sculptor Clive Soord led a team of students and staff from Canterbury College and the Canterbury School of Visual Arts in creating this remarkable, wooden installation as part of the Armistice centenary commemoration in 2018. The local community and a number of local businesses supported and helped fund the project, with the wood being donated by Jackson's Fencing and the rope supplied by the Historic Dockyard at Chatham. Some 8,000,000 horses were killed during the First World War and the Canterbury War Horse serves as a memorial to them and to the part played by animals in the armed forces during the conflict.

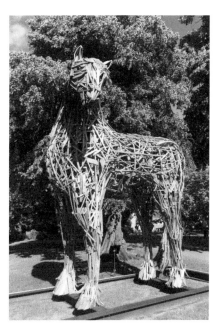

The Canterbury War Horse.

War Memorials

There are a number of tributes to the fallen of Canterbury located across the city. The Canterbury War Memorial, or Cross of Sacrifice, situated at the centre of the Buttermarket, was unveiled by Earl Haig in October 1921. It took years of research

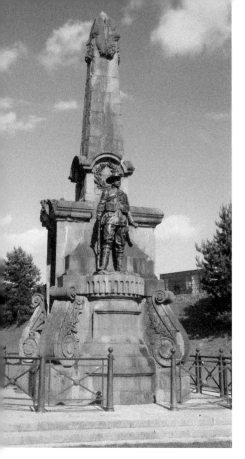 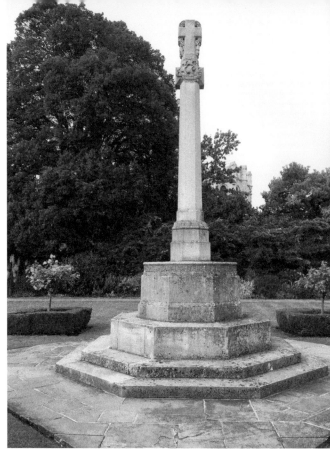

Above left: The Dane John War Memorial.

Above right: The war memorial which stands in the Kent County War Memorial Garden.

to gather the list of names now displayed – so long that the memorial was unveiled without them (the bronze plaques were added later) – and the cathedral archive houses the correspondence gathered to determine which names would be included. It was decided that only servicemen resident in Canterbury at the time of joining up were to be considered, but there are a few exceptions to this general rule. One unusual example is that of EFM Parker, whose initials give no indication of the fact that she was a woman, Ethel Frances Mary, serving with the Auxiliary Corps in France when she was killed in May 1918. On the other side of the cathedral precinct is the tranquil Kent County War Memorial Garden, a place for quiet contemplation maintained by cathedral staff. In the Dane John Gardens, an imposing obelisk commemorates the men of the Buffs and East Kent Yeomanry who fell in the Boer War, whilst a more subtle monument to that regiment stands, now, in the High Street (although it was originally erected at the end of the cattle market, in Lower Bridge Street).

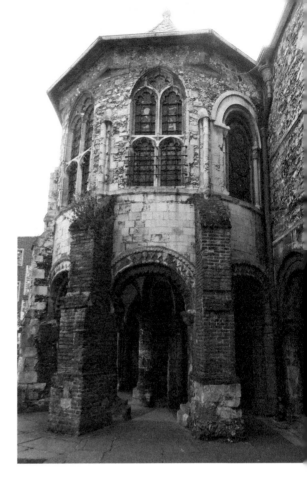

The cathedral water tower, part of an efficient and sophisticated twelfth-century water supply.

Water Tower

This twelfth-century construction, shown clearly on the contemporary Norman plan of the cathedral's waterworks, formed part of a sophisticated and efficient system for water supply and waste management. Travelling from its source around a kilometre north of the cathedral, fresh spring water was carried across farmland and orchard via a complex system of lead pipework and settling pools to be stored in a large tank in the tower, providing the Christchurch Benedictines with a reliable supply of fresh, clean water for all their daily needs, from washing and cooking to brewing and feeding their fish. Although sections of the tower were rebuilt at the turn of the fifteenth century, the original Norman dog-toothed arches are still evident.

Weavers

'Profitable and gentle strangers ought to be welcomed and not grudged at' was the advice of Archbishop Matthew Parker regarding the influx of religious refugees fleeing persecution in the Spanish Netherlands in the 1560s and it would seem that

the people of Canterbury took his instruction to heart: large numbers of 'strangers' began to make the city their home and it has been estimated that, at times, Walloons accounted for up to half the city's population. Although they practised a wide variety of trades, by far the most prevalent were weaving and the preparation of woollen cloth. A number of properties across the city provided accommodation for this trade and its workers and some can be identified by their 'weavers' windows' – long rows of glass panes which allowed maximum light to enter the workspace, usually on the upper floors. 'The Weavers' is a generous property dating from the 1200s, built along the riverbank at the King's Bridge over the Stour. It gives some insight into the scale of fabric production undertaken on such premises, a tradition which continued well into the nineteenth century when the property was occupied by an Arts and Crafts-inspired school of weaving.

French Huguenots followed their Flemish counterparts in the late 1600s and were quickly assimilated into the existing 'Stranger' communities and congregations around the city, but these people brought with them new skills and adapted to the new fashions of the seventeenth century: the French tradition of silk weaving began to replace the wool weaving associated with the older Walloon community and this was soon to give rise to a local product, the Canterbury Muslin. Woven from a mixture of wool yarn and silk fibres, the fabric was largely the creation, in the 1780s, of local businessman John Callaway (who owned The Weavers). Such was the popularity of this new cloth that, by the end of the 1700s, Callaway had been appointed muslin-weaver to Queen Charlotte and the Prince of Wales and it was said that every weaver in the city was employed in the production of his wares.

Below left: The Old Weavers' House dates from the 1200s but has been much altered through the centuries.

Below right: The Old Weavers' House windows overhanging the Stour.

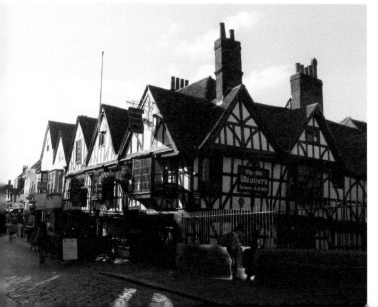
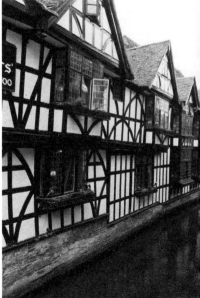

Westgate

This striking, 18-metre-high gatehouse is the largest medieval gate in the country and the last remaining survivor of Canterbury's defensive portals. It towers over St Dunstan's Street as it creeps its way through the gateway arch and into the city centre. There is evidence of a gate on the river, here, from the Roman period but the imposing edifice we see today dates from the fourteenth-century wall refurbishments designed by Henry Yvele, master mason to the Plantagenet court. The wooden gates which replaced the original drawbridge were burned during the Civil War but their replacements were in constant use until removed at the end of the eighteenth century.

From the mid-1400s, the gate towers served as the city jail – in addition to the county jail at the castle – and played host to several notable inmates, including several of the 'Maryan Martyrs' and Puritan Robert Cushman who was instrumental to the founding of the Plymouth Colony in Massachusetts. By the early 1800s, accommodation at the towers had become inadequate and a new prison site was constructed along the wall at Pound Lane (*see* Pound Lane Prison).

Below left: The Westgate Towers.

Below right: The Westgate's arched portal through which modern traffic still flows.

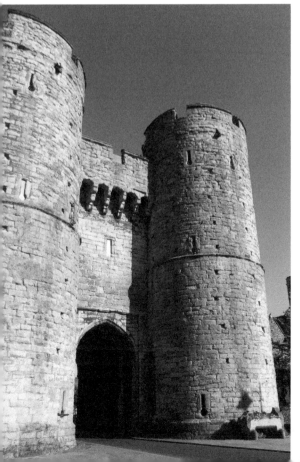

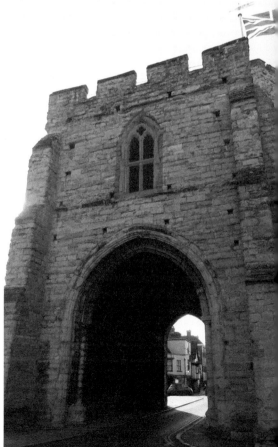

In 1906, the towers opened their doors to the public as a city museum but, a century later, found themselves under threat of closure. However, after extensive refurbishment, the Westgate Towers Museum was reopened in 2011.

Worthgate

Situated at the end of modern Castle Street, this was one of the Roman city gates but, when it was closed, travellers were sent, instead, to the nearby Wincheap Gate. Both gates are commemorated by Cozens stones* and the 'Farewell 1833' plaque reminds us of the courteous leave-taking of our ancestors: the other side bore a similar 'welcome' plaque greeting visitors as they arrived.

Above: The Worthgate Cozens stone marking the site of the original entryway.

Left: The 'Worthgate Farewell' sends visitors on their merry way.

X

Xmas Parade and Nativity Scene

The feast of St Nicholas falls on 6 December and this event is marked in Canterbury by a colourful and lively parade through the city's streets. Patron saint of Russia and Greece, St Nicholas is, perhaps, more familiar in the red-robed and bearded guise of the Dutch Sinterklaas, trudging through the deep December night to distribute gifts and sweets to well-behaved children. In Britain, the Feast of St Nicholas was celebrated in the widespread tradition of the 'boy bishop', observed between 6 December and the Feast of the Holy Innocents on 28 December. This custom saw the election of a single boy to head a group of comrades in replacing the bishop and his clergy for the month. Dressed in appropriate splendour, the boys would process the streets, blessing the townsfolk and performing all the clerical duties of their adult counterparts – except for the Mass. The Reformation sparked a repudiation of many of the Catholic saints venerated by our medieval forebears and many that were then familiar are now largely forgotten – but St Nicholas has proved a tenacious feature of the English Christmas tradition; his festival was banned under Henry VIII but was

The nativity crib scene at Canterbury Cathedral.

reinstated by Mary I and, despite outright abolition under Elizabeth I, there have been numerous twentieth-century reinvigorations of St Nicholas rites, including at Westminster and Salisbury cathedrals as well as at countless smaller parish churches across the country. Canterbury's December event marks the onset of Advent and harnesses the spirit of 'goodwill to all' in its collections for local and national charities. Accompanied by schoolchildren, musicians, singers and other locals in fancy dress, Saint Nicholas leads his procession through the city's streets, towards the cathedral, where he is met at the Christchurch Gate by the archbishop.

The cathedral nativity scene is a life-sized depiction of the night of Christ's birth, beautifully lit and with its own festive, musical accompaniment.

Xmas Market

The Canterbury Christmas market is an annual event that runs for the month leading up to Christmas Eve. From the end of November, the Whitefriars area of the town becomes home to a small village of seasonally decorated wooden cabins offering an array of gifts and decorations, food and drink and, of course, Santa's grotto. The market also boasts daily live music and street theatre events by local artists, groups and schools, as well as free arts and crafts activities and grand-scale games like the 'Look for a Book' treasure hunt.

Below left: Stalls at the Xmas market.

Below right: Xmas lights and decorations festoon the town in December.

Y

Ypres Stone

The Kent War Memorial Garden was created after the First World War in an area of the cathedral precinct adjacent to the ancient city wall. A square bastion in the wall was converted into a memorial chapel and the Ypres Stone, a block of masonry from the ruined thirteenth-century Cloth Hall in the Flemish city, was mounted in the wall to the side of the chapel entrance. The stone was presented by Ypres to Canterbury in honour and remembrance of the soldiers of The Buffs (East Kent) Regiment and West Kent Regiment who fell at Passchendaele, the Third Battle of Ypres. The Ypres Cloth Hall was fastidiously reconstructed over a period of thirty years from the 1930s and now houses the Flanders Fields Museum.

One of the city wall's square bastions was converted to create the memorial chapel in the Kent War Memorial Garden. The Ypres Stone is mounted in the wall to the left of the door.

Inset: The Ypres Stone in the War Memorial Garden chapel wall.

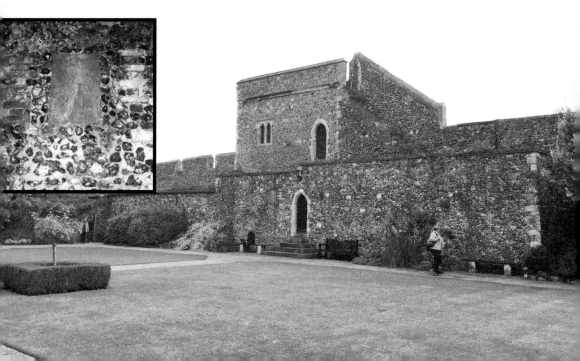

Yvele, Henry (*c.* 1320–1400)

Yvele was a prodigiously talented and successful master mason, working in the employ of Edward III and his sons, The Black Prince and John of Gaunt. Responsible for some of the country's most significant building works of the fourteenth century, including work at the Tower of London, Westminster Abbey, the Savoy Palace and Old Saint Paul's, Yvele was also commissioned to work on Canterbury's city walls and supervised the rebuilding of the Westgate. Much of his work has been lost or hidden in the intervening centuries; however, in the architecture of the nave and south cloister of Canterbury Cathedral Yvele's talent is abundantly apparent. Here, his use of the emerging Perpendicular Gothic – with slender, elegant pillars, soaring arches, lierne vaulting and tall, traceried windows – gives the nave a tremendous feeling of space and light. Unusually, today's cathedral visitor can catch a glimpse of Yvele himself as his portrait forms one of the bosses in the cloister ceiling, which was constructed in the years immediately following Yvele's death in 1400.

Henry Yvele's likeness in a ceiling boss in the cathedral cloisters.

Z

Zoar Chapel

This wall bastion served as the city conduit from the start of the nineteenth century; however, after much-needed improvements to the water supply, the building was sold to the Zoar Strict & Particular Baptist community in 1845. This unusual name is found for just a handful of Strict Baptist chapels across the south-east of England, with a particular concentration in Sussex. The city of Zoar, for which they are named, was one of the biblical 'cities of the plain'; described as a beautiful and luxuriant oasis, Zoar, or Zoara, was spared the 'brimstone and fire' that devastated Sodom and Gomorrah. The word also translates from the Hebrew to mean 'small', which might be a reference to the size or exclusive nature of the group that formed the community here.

The Zoar Chapel occupies one of the city wall's former gun ports.

Notes

* Cozens stones: Walter Cozens was a prominent Canterbury builder, City Councillor and founder member of the Canterbury Archaeology Society. A dedicated historian and archaeologist, in the 1920s, Cozens instigated a scheme to mark the sites of Canterbury's lost historic landmarks and laid a number of inscribed paving slabs, now known as 'Cozens stones', across the city. Fourteen of his stones are still visible today.

S

1. 'Houses of Benedictine nuns: The priory of St Sepulchre, Canterbury', in *A History of the County of Kent*, Volume 2, ed. William Page (London, 1926), pp.142-144. British History Online http://www.british-history.ac.uk/vch/kent/vol2/pp142-144 [accessed 27 September 2019].

U

1. https://www.thecompleteuniversityguide.co.uk/league-tables/rankings

V

1. Garmonsway, G. N., *The Anglo-Saxon Chronicle* (J. M. Dent & Sons Ltd, 1986), p.65
2. Ibid., p.141
3. Ibid., p.142
4. Ibid., p.142

Bibliography

British Library (https://www.bl.uk)

British Listed Buildings (https://britishlistedbuildings.co.uk)

BHO British History Online (www.british-history.ac.uk)

Canterbury Archaeological Trust Ltd. (http://www.canterburytrust.co.uk)

Canterbury Historical & Archaeological Society (CHAS) (http://www.canterbury-archaeology.org.uk)

Historic Canterbury (http://www.machadoink.com)

Garmonsway, G. N., *The Anglo-Saxon Chronicle* (London: J. M. Dent & Sons Ltd, 1986)

Hasted, Edward, *The History and Topographical Survey of the County of Kent: Volume 11* (Canterbury, 1800), pp.78-81. British History Online http://www.british-history.ac.uk [accessed 12 September 2019].

Lyle, Marjorie, *Canterbury 2000 Years of History* (Stroud: Tempus Publishing Ltd, 2002)

Lyle, Marjorie, *Canterbury History You Can See* (Stroud: Tempus Publishing Ltd, 2008)

Maxwell, Donald, *Unknown Kent* (London: The Bodley Head, 1921)

'Houses of Benedictine nuns: The priory of St Sepulchre, Canterbury', in *A History of the County of Kent*, Volume 2, ed. William Page (London, 1926), pp.142-144. British History Online http://www.british-history.ac.uk/vch/kent/vol2/pp142-144 [accessed 27 September 2019].

https://www.thecompleteuniversityguide.co.uk/league-tables/rankings

Acknowledgements

With my love and thanks to Grace for being my sounding board (as always), to Will for the long walks and extra photographs and to Paul for giving me a place to work.

Thank you to the team at the Canterbury Cathedral Archives Department, without whose generous support this project would have been far less successful – especially Cressida Williams, Toby Huitson and Daniel Korachi-Alaoui, for their assistance with the cathedral photographs and permissions.

Thank you also to Jason deCaires Taylor, Jan Leeming and Canon Ian Black for their kind generosity in allowing me to use their own photographs, and to the team at Amberley – particularly my commissioning editor Angeline – for their encouragement and support in this project. Finally, I would like to acknowledge the many thousands across the centuries – anonymous and famous alike – whose stories, great and small, have contributed to the enthralling narrative of Canterbury.

The photographs in this book are my own with the following exceptions, which have been reproduced here by permission of their owners: Alluvia river sculptures photographs reproduced by kind permission of Jason deCaires Taylor (www.jasondecairestaylor.com); photograph of Canterbury Cathedral tower treadwheel reproduced courtesy of the Chapter of Canterbury; photographs of Stephen Langton's tomb reproduced by kind permission of Canon Ian Black. All photographs of Canterbury Cathedral are presented here with the permission of the Chapter of Canterbury.

About the Author

Naomi Dickins lives in the heart of the Kent Weald with her husband, two children and assorted animals. After reading History at Bristol University and gaining an Advanced Diploma in Local History Studies from Oxford University, she has worked as a tutor and lecturer, researcher and archivist. As well as writing and lecturing, Naomi runs classes and workshops for local history groups.